KT-119-154

ACRYLICS
MASTERCLASS

HarperCollins*Publishers*

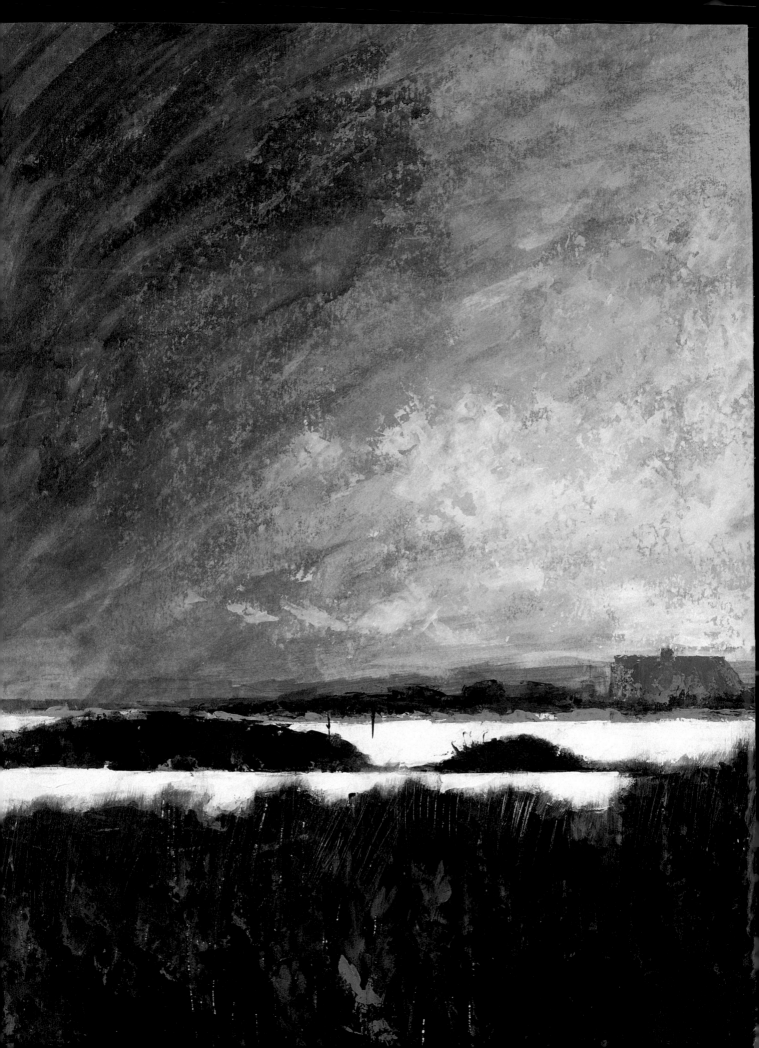

SALLY BULGIN

ACRYLICS
MASTERCLASS

LEARNING FROM PROFESSIONAL ARTISTS AT WORK

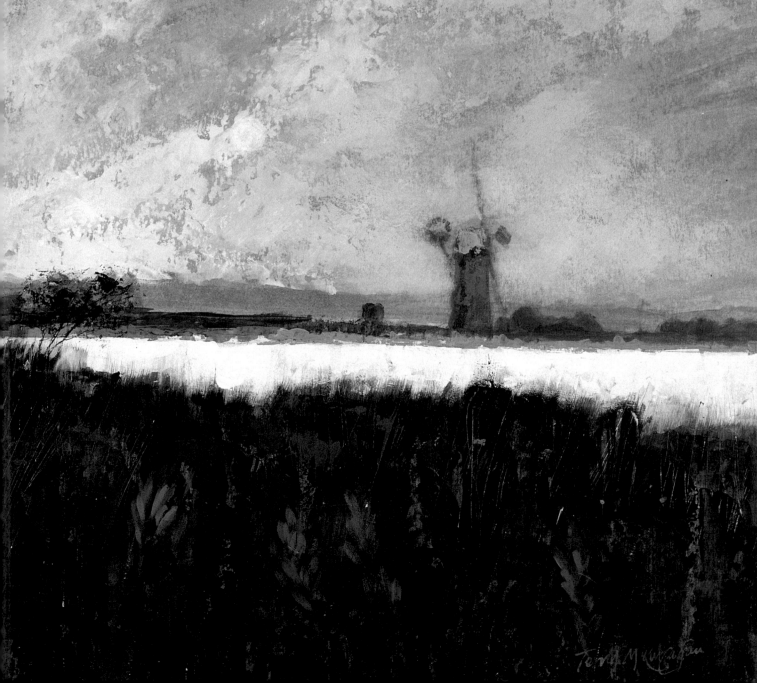

ACKNOWLEDGEMENTS

*The author would like to thank all the artists
represented in this book for their enthusiasm and
co-operation; without their help it could not have
been produced. Many thanks also to
Nigel Cheffers-Heard and Jon Wyand for
photographing some of the paintings and
demonstrations; to Cathy Gosling,
Caroline Churton and Caroline Hill at HarperCollins;
to Geraldine Christy and Glynis Edwards;
and to all those people without whose support I
could not have completed this book.*

STOCKTON - BILLINGHAM

LEARNING CENTRE

COLLEGE OF F.E.

751.426

First published in 1994 by
HarperCollins Publishers, London

© Sally Bulgin, 1994

Sally Bulgin asserts the moral right to be identified as
the author of this work.

All rights reserved. No part of this publication may be
reproduced, stored in a retrieval system, or
transmitted, in any form or by any means,
electronic, mechanical, photocopying, recording
or otherwise, without the prior written permission of
the publishers.

**A catalogue record for this book is available from the
British Library**

ISBN 0 00 412839 7

*Editor: Geraldine Christy
Art Editor: Caroline Hill
Designer: Glynis Edwards*

Set in Optima and Weiss
Colour origination by Colourscan, Singapore
Produced by HarperCollins Hong Kong

PAGE 1: Sally Bulgin,
This Way Up,
1370 × 1220 mm
(54 × 48 in)

PREVIOUS SPREAD:
Terry McKivragan,
Norfolk Broads,
510 × 685 mm (20 × 27 in)

CONTENTS

INTRODUCTION 6

ACRYLICS IN CONTEXT 8

MATERIALS AND TECHNIQUES 12

MASTERCLASS *with Terence Clarke* 32

MASTERCLASS *with Peter Folkes* 42

MASTERCLASS *with William Hook* 52

MASTERCLASS *with Moira Huntly* 62

MASTERCLASS *with Donald McIntyre* 72

MASTERCLASS *with Terry McKivragan* 80

MASTERCLASS *with Leonard Rosoman* 92

MASTERCLASS *with Jack Shore* 106

MASTERCLASS *with Ian Simpson* 118

ARTISTS' BIOGRAPHIES 128

INTRODUCTION

A masterclass is a form of teaching in which the student learns from a professional artist by observing his or her ideas and working methods in practice. The idea of this form of teaching is not for the professional to impart guidelines about what to do or what not to do; after all there are no absolute rules about what you should paint and how. Instead, the intention is for the professional artist to share with the student valuable information gained through personal experience on ways of handling a medium, to convey the thinking process behind making paintings, and to inspire by example.

In *Acrylics Masterclass* nine professional artists, whose subject matter and techniques reveal the wide-ranging and exciting potential of this versatile medium, discuss their ideas and approaches. In doing so they provide an illuminating insight into their working methods and offer you the benefit of their experience and hard-earned knowledge.

You may, of course, feel more empathy for some of the works reproduced in *Acrylics Masterclass* than others – we all have very different ideas and aspirations for our own work. However, we can all learn something of immediate usefulness from each of the artists represented here. They have been generous in explaining their thoughts and techniques, and the information they have provided will stimulate both the newcomer to acrylics and more practised artists who may not yet have discovered the full potential of this medium.

As you will see, compared with the long tradition associated with oil painting, acrylics are a relatively new paint for artists, with a number of important advantages over oils. The exciting potential in this for the trained and the untrained painter alike is that both are free to experiment with the medium, unhampered by the strictures of professional teaching and opinion. The use of acrylics presents the painter with more freedom and more possibilities than ever before.

One of the greatest assets of the acrylic medium is its versatility. It can be applied in washes or glazes or in thick impasto brush strokes; colours can be overlaid without fear of cracking and painted one over the other in quick successive layers since, unlike oils, the paint dries rapidly. It is simple to use and clean to handle – no messy diluents are necessary.

A work in acrylic can display a variety of visual effects – it can be softly atmospheric and transparent, or an opaque mass of brilliant colour and light; or it can combine these characteristics in one work. Acrylic paint is resilient and flexible; it can be applied to all kinds of surfaces; it can be brushed, poured, dragged, scraped, scratched, stained, tubed, sprayed, even thrown onto the support. In addition it can be mixed with a variety of different mediums to create a wide range of surfaces and textures.

All these elements in one way or another provide the excitement and inspiration behind the work of the artists in *Acrylics Masterclass*. By studying and absorbing their ideas and working methods you will discover for yourself the enormous amount of pleasure to be experienced from an exploration of this medium. I hope you will find the information and ideas imparted by the artists here as inspiring and stimulating as I have done. I have learned something from each of them; I have also thoroughly enjoyed working with them, and am delighted to share their enthusiasm for the acrylic medium in this book.

Sally Bulgin

ACRYLICS IN CONTEXT

Acrylic paints were first developed for industrial application in the early part of the twentieth century, and until the late 1950s and early 1960s their use was restricted to this field. When artists first became aware of the possibilities of the medium for fine art and began to use acrylics in the late 1950s these paints became an important new addition to the artist's repertoire of painting materials. Acrylics have subsequently contributed significantly to the development of twentieth-century painting techniques.

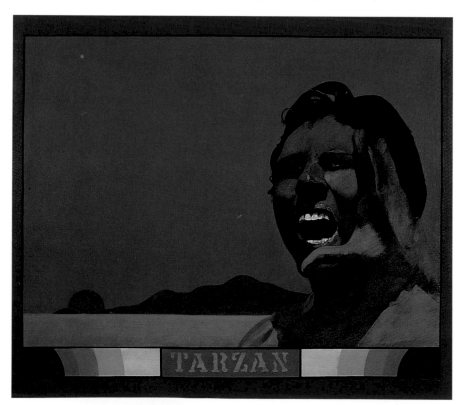

Peter Blake,
Tarzan 1964/5
acrylic on canvas
510 × 610 mm (20 × 24 in)
REPRODUCED COURTESY OF
DALER-ROWNEY

Pop and abstract artists were the first to explore the exciting new potential of acrylics. Pop artists like Peter Blake exploited the bold, intense colours to emphasize the spirit of the bright modern world of popular culture and the consumer society which furnished them with a new source of imagery and inspiration.

Peter Blake was one of those asked by George Rowney and Co. to test their new acrylic paints when they were first introduced in the UK in 1963. Tarzan now hangs at the company's offices at Bracknell, Berkshire. Its simple design, painted in bright, flat colours with no sign of brushwork, is typical of Blake's work of the late 1950s and early 1960s and is a style of painting well suited to the fast-drying, bright, clean colours of acrylic paints

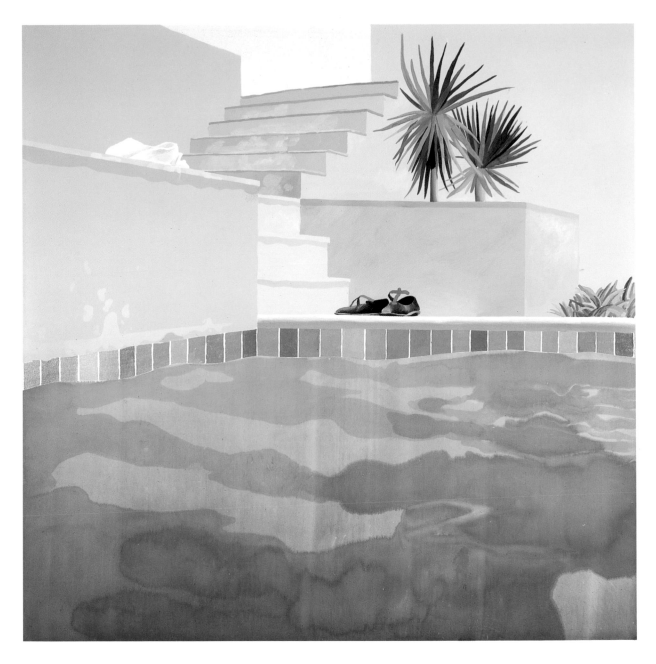

HOCKNEY'S CONTRIBUTION

In the 1960s artists such as David Hockney contributed to the growing popularity of the medium amongst figurative painters. He began to use acrylics during his first visit to California in 1964 since their speed of drying allowed him to work on one picture from start to finish, rather than two or three oil paintings at a time. His switch to acrylics coincided with a technique that was more pre-planned, and with the subsequent appearance of water as a major subject in his work – showers, swimming pools (as in *Pool and Steps, Le Nid du Duc*), lawn sprinklers, for example – he began to explore the effects of reflection, translucence and of shimmering light on the surface of water in his paintings.

Hockney began to adapt techniques used by American abstract painters like Helen Frankenthaler,

David Hockney,
Pool and Steps, Le Nid du Duc *1971*
acrylic on canvas
1830 × 1830 mm (72 × 72 in)
© DAVID HOCKNEY
David Hockney's adoption of the acrylic medium in the 1960s contributed to its growing popularity amongst figurative painters

Kenneth Noland and Morris Louis to obtain his watery effects. He began to add a little detergent to his acrylic paints which he diluted with water. When he painted this straight onto unprimed raw cotton duck, the detergent broke down the oil in the cotton, making it more absorbent and allowing the paint to stain into the canvas. To make the rest of the canvas entirely different in feeling to this stained watery area he would underpaint with an acrylic gesso ground before painting on top; this had the effect of creating two different textures in the same painting.

The addition of detergent to the acrylic increased the drying time of the paint to around three to four hours. This meant that Hockney could manipulate his washes on the canvas. He was able to paint a wash of deep blue, for example, and then overlay washes of lighter blue; or, more easily, dark over light. He was also able to rearrange shapes within a painting during the couple of hours when the paint remained damp.

Today, you can add retarder to the paint to prolong its drying time if necessary and, as you will see from the work of the *Acrylics Masterclass* artists, acrylics are now used by many painters whose working methods and subject matter vary enormously. Significantly, they also recommend acrylics as ideal for inexperienced painters because of their many practical advantages; they are relatively new, exciting and incredibly flexible, and providing a few principles are adhered to, they offer a long-lasting and durable medium with which you can achieve an enormous range of effects.

Terry Frost,
Pink Sun Sail *1984*
acrylic on canvas
813 × 813 mm (32 × 32 in)
REPRODUCED COURTESY OF
THE ARTIST

Terry Frost is among the many British abstract artists who first began to use acrylics in the early 1960s, finding them useful for their colour intensity, quick-drying nature and the freedom of approach that they encouraged. In this later work he has used bright acrylic hues to evoke the joyous phenomenon of a blazing sun – a typical theme in his work

John Plumb,
Red over Zircon *(diptych)*
May 1966
PVA and acrylic compound
emulsion on canvas
810 × 405 mm (32 × 16 in)
REPRODUCED COURTESY OF THE
TADEMA GALLERY

Abstract painters like John
Plumb, in the early 1960s,
were delighted to discover a
medium which could be used to
stain huge areas of canvas to
create vibrant fields of colour.
In a period of art history
when speed of execution,
spontaneity, experimentation
and large scale were important,
acrylic paints offered the
ideal medium

John Plumb,
Hydrastructure – Blue
Up, Green Down *1993*
acrylic on canvas
1830 × 1830 mm (72 × 72 in)
REPRODUCED COURTESY OF
THE ARTIST

John Plumb now uses acrylics
to develop rhythms and linear
structures that relate to his
interest in the movements of a
river. He limits the use of
brushes, using instead large
spatulas, filling knives, and
even pastry piping tools with
interchangeable nozzles, or he
squeezes paint direct from the
tube onto the canvas, to create
broken areas of texture as well
as snake-like elements. These
marks suggest reflections and
the eddies and ripples of the
water surface. Like his earlier
colour-field paintings, however,
his abstract compositions evolve
out of the process of painting

Materials and Techniques

All artists' paints consist of pigments – solid colouring matter – bound by a medium which fixes the colour in the dry paint film. The major difference between one paint and another lies in the nature of the binder, which largely decides the character and behaviour of the various paints; their permanence, speed of drying, working qualities and brilliance. The special properties of acrylics depend on the nature of acrylic binders, so it is important to understand how these affect the behaviour of the paint if you are to discover their full potential.

Before the introduction of synthetic resins as binding mediums a variety of natural substances including linseed oil, nut oil, poppy oil, egg yolk and beeswax were used for this purpose. But the use of these natural substances has led to a range of problems over time, in particular with regard to ageing, cracking, yellowing, stability to light and dark, water, air and other factors.

The latest advances in modern chemical science have made possible the elimination of many of these problems, however, through the development of synthetic resins as binders for artists' quality paints. Unlike the natural products adapted to make oil paint, watercolour, gouache, tempera, wax encaustic and so on, acrylic binders are made specifically for the job intended for them. In simple terms an acrylic binder is a plastic, with great adhesive qualities, which is water-soluble when wet and which provides a highly durable, flexible and water-resistant film on drying.

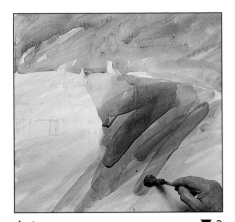

▲ 1

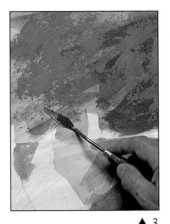

▲ 3

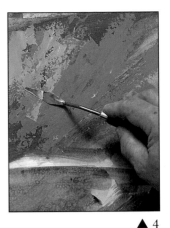

▲ 4

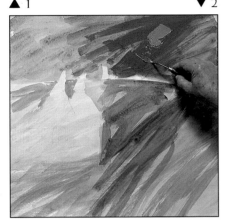

▼ 2

Glazing and Impasto

In this sequence you can see how Terry McKivragan starts by applying acrylic paint loosely and quickly in thin glazes using a soft mop brush and bold, vigorous brush strokes (1). Because acrylic paint dries quickly, you can develop successive glazes of transparent colour in rapid succession to build up complex and subtle areas of colour with great depth and translucency.

Once the general under-painting is established Terry applies impasto colour thickly with a palette knife (2). When buttery-consistency paint is used in this way in the form in which it is squeezed from the tube, it retains the mark of the palette knife, brush or whatever implement is used to apply it

Broken texture

Terry uses texture expressively to develop atmospheric skies and other landscape elements. By dragging thick, buttery paint across the painting surface with the edge of a palette knife, you can achieve areas of broken, opaque colour, through which the underneath colours will show. This keeps the colour and surface quality of the painting alive (3).

Again, because these thicker areas of paint dry so quickly, you can go on modifying and building up subtle, atmospheric colour harmonies almost immediately, without any fear of the underneath colours

blending with and muddying those applied on top. This encourages a bold and direct method of painting in which, if you like, the picture can be completed in one sitting (4).

The layers of transparent glazes and broken, opaque colour, give the final paint surface of Terry's Oast Houses (735 × 735 mm, 29 × 29 in) great depth, which is an important aspect of any picture and can be enjoyed as much for its own sake as its descriptive and atmospheric qualities (5)

▼ 5

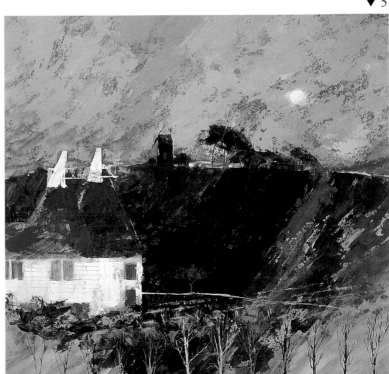

Pastel over acrylic
A combination of media can contribute particular qualities of texture and colour, as Moira Huntly shows, as well as add to the mood of a subject

Wash-out technique
An especially useful technique for developing the subtle, mottled tonal effects of skies, for example, is, as Moira Huntly demonstrates, to apply your wash to the surface of your paper and then run this under the tap, or go over it with a large brush loaded with clean water, before the first wash is dry

A PERMANENT PAINTING MEDIUM

Many of the artists represented in *Acrylics Masterclass* select colours from different brands to build up their own personal palettes. If you follow their example you should first test their compatibility since the exact chemical structure of the acrylic resin binder can differ from brand to brand. Artists' acrylics also contain additives such as stabilizers and thickeners which again will make each brand slightly different in performance.

The quick-drying nature of acrylics is regarded by the *Acrylics Masterclass* artists as one of its greatest assets. Unlike oils, which dry by a slow process of oxidization, acrylics dry by evaporation of the aqueous part of the paint.

Drying time can vary from a few minutes to several hours depending on the thickness of the paint and humidity of the atmosphere, making them ideal for outdoor work, as Ian Simpson demonstrates (page 118). Unlike oils impasto dries in hours rather than weeks and once dry a canvas can be rolled up, stored and re-stretched years later with no danger of the paint surface cracking. This is also useful for sending paintings on canvas through the post as they can be rolled up, packed in a postal tube and sent at a fraction of the cost of crating.

Another advantage over oils, which may yellow with age, is the fact that acrylics are non-yellowing; nor do they become brittle and more transparent over time like oils, which can lead to layers of underdrawing or underpainting showing through the oil-painted surface. Artists' quality acrylics offer the painter a flexible, highly durable and permanent painting medium.

GEL AND FLUID CONSISTENCY ACRYLICS

Acrylic paints are available in several different forms. Artists' quality acrylics are generally obtainable in a gel consistency and have a buttery texture which is similar to oil paints when squeezed straight from the tube. This soft paste is relatively thick; it is easy to handle, it retains the brush stroke well – or it can also be applied with a painting knife, and it can be easily thinned with water or an acrylic medium to produce fine washes. These artists' quality acrylics are mostly available in tubes, although some manufacturers also offer the paint in larger size plastic containers, in which case the paint may have a slightly more fluid consistency.

As well as gel-consistency acrylics, liquid-consistency acrylic colours, sometimes described as 'flow' acrylics, are also available. These are bound by the same acrylic polymer emulsion as full-bodied acrylics, but formulated to a thinner consistency. These more fluid acrylics are ideal for covering very large areas such as exterior and interior murals, but can also be used on any suitably prepared, grease-free surface. They are also ideal for use with an airbrush, as long as the equipment is thoroughly cleaned with water immediately after use.

Some manufacturers market their 'flow' acrylics as 'second' or 'student' ranges, although a number of fluid ranges are artists' quality paints offering highly pigmented, lightfast colours. Again, check the manufacturer's product information to be certain about what you are actually buying.

Many of the colours in the student quality fluid ranges of acrylics

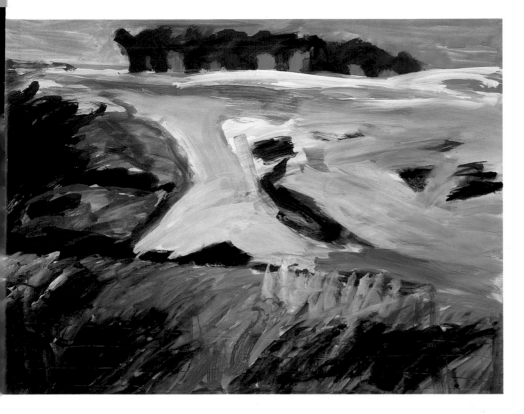

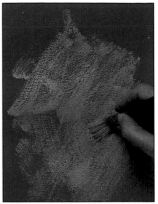

▲ Scumbling
Passages of sparkling, optical colour mixtures can be achieved by scrubbing dryish paint briskly, using a stiff bristle brush, over an underlying colour so that the base colour shows through the broken colour on top. The base colour, in this example Cadmium Red, modifies the overlying colour, Cadmium Orange, without obliterating it. This technique is useful for toning down a colour that is too bright, or brightening a colour that is too dark – or it can help to bring together an area in which there is too much tonal contrast. As you move away from an area of broken colour, the more the separate colours will be read as a single, new colour

▲ Sgraffito
In her painting on paper
Across the Dyke, Winter
(840 × 1145 mm, 33 × 45 in), Judy Martin has suggested the presence of a fence in the bottom foreground of this boldly painted landscape by scratching through the loosely applied colour areas, using the tip of an oil pastel, as you can see in the detail (RIGHT).

By using the sgraffito technique to scratch through one colour before it has dried to reveal an underlying colour, you can create patterns, outlines, interesting textural effects, and the optical mixing of broken colour. Any pointed tool can be used for this purpose, including the end of a brush handle, the tip of a palette knife or a pencil

◀ Blending wet-in-wet
By working quickly wet-into-wet, onto wet paper, subtle transitions from one area of colour to another can be achieved, avoiding hard edges. The two colours will bleed into each other, creating softly blurred forms

▲ Glazing over
opaque paint
*Glazing with thin transparent
washes over opaque colour is
an effective technique for
portraits and figure painting,
where colours and tones must
be subtle and carefully
modulated. Transparent glazes,
such as the brush strokes of
diluted Cadmium Red here,
over an opaque base colour –
here Cadmium Yellow – will
allow the base colour to shine
through and contribute a
luminous quality to the
paint surface*

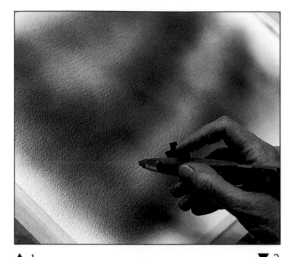

▲ 1 ▼ 2

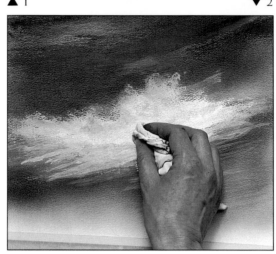

◀ Airbrushing
*As long as the equipment is
thoroughly cleaned with water
immediately after each colour
is used, acrylics can be diluted
with water and applied with
an airbrush. Here the artist has
airbrushed separate layers of
Ultramarine, Deep Violet and
Payne's Grey, followed by
more Ultramarine onto the
paper surface to create a softly
mottled effect. This technique
can provide an ideal base for
creating subtle sky effects (1).*

*Additional colours can then
be feathered and blended onto
this surface with brushes and a
rag to suggest clouds, as this
example shows (2)*

are made with less costly pigments
and are less expensive than artists'
quality acrylic paints. Expensive
pigments such as the cadmiums
may have been replaced in these
student ranges with highly lightfast
synthetic organic pigments.

Fluid-consistency acrylics come
in tubes as well as larger containers
such as wide-topped tubs and jars
or plastic bottles with nozzles,
which can often be more conve-
nient for artists like Leonard
Rosoman who use large quantities
of colour.

MAKING YOUR OWN PAINTS

For economical reasons many pro-
fessional artists, particularly abstract
painters who work on a large scale,
and theatrical scene painters, who
use large quantities of acrylic
colours, sometimes prefer to make
their own paints. This is easy to do
using the concentrated colour pastes
and aqueous dispersion colours, or
stainers, which are available from
specialist art shops. These colouring
ingredients can be mixed with an
acrylic polymer emulsion disper-
sion binder to form an acrylic paint,
and then altered in consistency or
texture by the addition of a variety
of acrylic mediums (see Mediums
on page 20).

▲ Impasto brush marks
*By using creamy paint, and
adding either texture paste or
gel medium, you can build up
rich, textural qualities in
which the mark of the brush is
retained. These marks can
describe form, suggest texture
or be used expressively*

◀ Acrylic underpainting
Acrylics can be used to set the key for development of the subject in another medium. For Bandstand Study (510 × 760 mm, 20 × 30 in) Judy Martin put down a basic pattern of strong acrylic colours, freely applied with a housepainter's brush on smooth paper, before applying sweeping strokes of pastel, and dragging and scribbling pastel colours over these initial transparent washes. These underlying colours break through the pastel, creating a rich and complex textural surface

▼ Mixed media collage
Acrylics are ideal for mixed media collages because of their excellent adhesive qualities. You can embed other materials into the paint on the support or use texture paste to incorporate heavy or highly textured materials. Acrylics do not change colour or become brittle

with age, and as they dry to a clear, tough, flexible film, they offer a permanent means of holding together the various elements of a collage.

In Crowds and Crowds *(510 × 760 mm, 20 × 30 in), based on the crocuses at Kew Gardens, Jill Confavreux applied acrylic washes in*

broad simple areas onto watercolour board, before collaging on coloured tissue paper, using acrylic gloss medium to glue the paper to the painting. Further layers of paint, collage, and finally, oil pastel were added until she achieved a satisfactory image of her memory of the scene

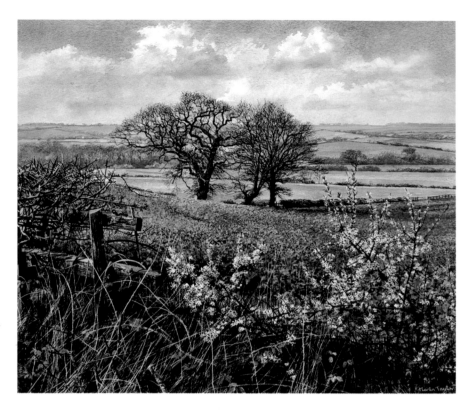

PVA COLOURS

Polyvinyl acetate paints are a less expensive alternative to acrylic paints, but the pigment is bound by a vinyl emulsion, so they tend to be inferior to artists' colours in quality and lightfastness. Although ideal for schools, you should avoid PVA colours if you are concerned about the longevity of your work.

PIGMENTS

Today a wide range of pigments is available, although sometimes the names given to colours by different manufacturers give little clue about their quality or behaviour. To add confusion to a wide choice some colours are sold by different manufacturers under different names, making it difficult for you to make direct comparison across brands. Manufacturers' colour charts will help by providing information on

the range and tone of the manufacturer's selection, the names of the colours and details about their use and permanence, although charts made with printers' inks to show the range of colours will not always reveal their true qualities.

Moreover, when you start to use acrylics you may find that a colour seems lighter in the tube than when it has dried on your surface. This is because the acrylic polymer emulsion used as the vehicle to bind the pigments to make artists' quality acrylic colours has a milky appearance when wet, but after drying it becomes transparent, so revealing the true colour and brilliance of the pigment. This effect is stronger in colour mixtures containing white than in those containing the cadmiums. Iron oxide colours mixed with white, moreover, appear warmer in tone when wet compared with their dried appearance.

The most helpful way to decide the colours you need is to make up

Acrylic and watercolour
Martin Taylor applies transparent washes of white acrylic to the colours in the background elements of his watercolour landscapes in order to achieve a greater sense of distance by 'knocking' these colours back. The use of thin layers of white acrylic also enables him to layer successive glazes of colour in his watercolours in a technique similar to glazing with oils — except of course in this case the work can be done much more quickly. It also enables him to work back into a watercolour light onto dark.

The fine lines of grasses, as in April Landscape with Blackthorn Blossom *(335 × 395 mm, 13¼ × 15 ½ in), are achieved by painting them in with a fine 000 size brush loaded with acrylic paint, using combinations of mixtures of White, Azo Yellow Light and Azo Yellow Medium. Because acrylic dries so quickly, he is then able to wash over these lines, overlap and cross-hatch more lines, then wash over them again in watercolour, until the required depth is achieved. Azo Yellow Light and Azo Yellow Medium acrylics mixed with Payne's Grey watercolour also gives Martin some of his rich greens*

your own colour chart for reference. The type of ground you use, consistency of paint and any additional mediums you add will also affect both the colour and texture of your paint. More information about pigments is available in Ralph Mayer's *The Artist's Handbook of Materials and Techniques* (Faber).

Pigments usually come in the form of powders made from inorganic and organic raw materials. Inorganic materials are of purely mineral origin and include the natural earths such as the ochres, raw umber and raw sienna, which can be calcined to make burnt umber and burnt sienna, and artificially prepared colours like zinc oxide and cadmium yellow. However, the natural earths, for example, contain too many impurities and are too difficult to disperse into the acrylic binder so synthetic iron oxides are used instead which have high tinting strength, intensity of colour and are totally lightfast.

Organic pigments come from animal and vegetable substances as well as complex synthetic substances. Many of these have now been replaced by artificially prepared organic colours such as alizarin and the phthalocyanine range which includes the very intense blue known under the name Monestial blue, yellows, reds, greens and a bright violet. These are all derived chemically from an organic dyestuff and are intense, highly durable colours. The quinacridones, phthalocyanines, naphthols and azos especially are extremely brilliant, beautiful colours with great depth and purity. These colours are used to great effect in Donald McIntyre's harbour scenes and seascapes.

Brilliant colours
Donald McIntyre exploits the brilliance of acrylic colours in his seascapes, using Azo Yellow, for example, to add the sparkling effects of sunlight on the rocks in scenes such as Rocky Coast, Iona *(510 × 760 mm, 20 × 30 in)*

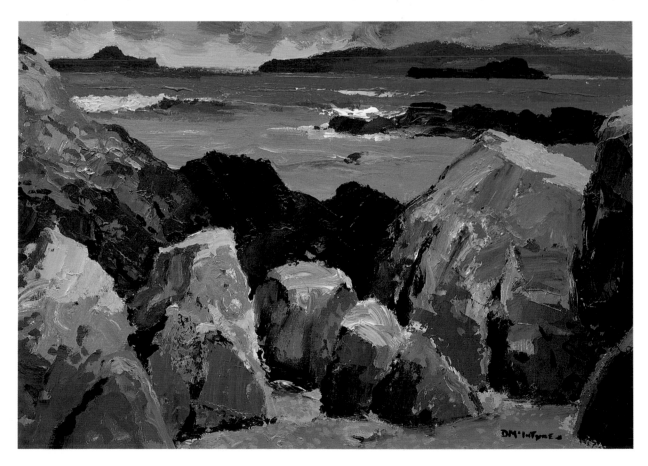

▲ Oil pastel resist
Interesting and lively effects can be achieved by combining the use, first, of oil pastels, which act as a resist when you apply washes of thin acrylic colour over the top

▲ Acrylic mediums
*From the top: Red Violet straight from the tube
Red Violet plus matt medium
Red Violet plus gloss medium
Red Violet plus texture paste*

NEW COLOURS

Newer pigments are also available in acrylic ranges. The use of mica pigments – titanium flakes coated with iron oxides – provides iridescent or 'interference' colours. These have a glittery appearance according to the play of light and will give a work a sparkling effect depending on the angle at which it is viewed. Painted in glazes over bright colours these will give paintings a more dazzling effect.

Metallic colours such as pewter, gold, silver, brass and bronze are ideal for decorative work on furniture and picture frames as well as for more traditional painting. Fluorescent colours are also available, although these are not usually completely lightfast.

The degree of lightfastness varies between different pigments. Most manufacturers provide a scale of lightfastness ratings and in quality ranges pigments are carefully selected to ensure lasting colours.

MEDIUMS

To exploit the enormous potential of acrylics to the full, it is useful to see the various ingredients which make up acrylic painting as parts of a system of interchangeable components. By experimenting you will quickly discover how different combinations of acrylic colours with the wide range of acrylic mediums available will produce quite different effects. An awareness of the possibilities open to you is essential to any mastering of acrylic painting techniques, even if you decide that many of them are not useful for your own style of painting. Essentially, you have the means to change the basic appearance of the dried paint film from matt to satin to gloss, to alter its consistency to a very thick paste-like texture or to very thin watery washes, and to produce different effects such as impasto and glazes.

ACRYLIC GLOSS MEDIUM

Acrylic gloss medium enhances the translucency of acrylic colours. The term 'gloss' is misleading as acrylic gloss mediums will not give the level of gloss found in oil mediums. The addition of acrylic gloss medium to the paint reduces its consistency to produce thin layers which dry rapidly. Its use means that many glazes can be quickly built up to produce colours of exceptional depth, clarity and brilliance.

Basically, acrylic gloss medium is the acrylic polymer emulsion used to bind acrylic colours. A small amount added to watercolours or gouache will alter them to behave in the same way as acrylic colours: they will become quick-drying, water-resistant, their finished surface will become more glossy in appearance and you will be able to paint over the dried surface without the problem of picking up the colours underneath.

ACRYLIC MATT MEDIUM

Matt mediums are thicker than gloss mediums because of the presence of the matting agents. Acrylic matt medium is simply the gloss medium to which a matting agent such as a wax emulsion or silica has been added. By adding small amounts of acrylic colour to a matt medium when painting transparent glazes for example, the mattness of the colour will be retained.

▶ Spattering
Interesting textural effects can be developed by spattering acrylic colours from the brush onto a painting – an effect which Peter Folkes exploits in the image of the cow in Cow and Gate *(355 × 535 mm, 14 × 21 in) in which the different textures highlight the contrast between the form of the cow and the broken gate*

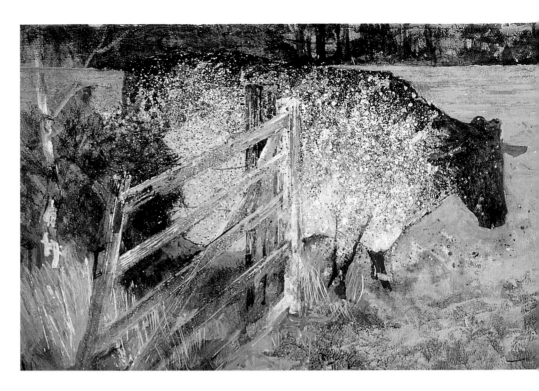

◀ Sketching with acrylic and pencil
Pencil and acrylic paints provide Ian Simpson with an ideal mixture of sketching media for his on-the-spot landscape studies. In this sketch, Landscape Suffolk *(420 × 595 mm, 16¹/₂ × 23¹/₂ in), he indicated the main shapes in pencil before rapidly blocking in broad areas of colour using both thin and opaque applications of paint. By drawing through the wet paint with pencil, he has added a graphic quality to the work and effectively suggested some of the delicate, willowy forms typical of this natural scene*

ACRYLIC GEL MEDIUM

This is a gloss medium which has been thickened to a jelly-like consistency. It allows textured impastos to be produced without losing the consistency of the colour; and because it dries to a transparent finish it also increases translucency.

The addition of gel medium to produce impasto enables you to introduce dynamic and expressive surface textures to your work. It affords you the opportunity to create just as much vitality in acrylic painting as the use of impasto does in more traditional oil painting – for example, the expressive surfaces of Van Gogh's paintings – but the advantages are that the thicker layers of paint dry much more quickly than oils and, once dried, they are less likely to crack.

Gel medium, like gloss medium, can also be used to make glazes, although with gel medium these will be thicker in consistency than glazes made with gloss medium. Glazing in oil painting can be a very long drawn out procedure as it can take months for a painting to dry enough to be able to paint a transparent film of colour over its surface. Furthermore, you can only glaze with one layer of colour in oils, whereas with acrylics you can overlay many transparent glazes of different colours, each of which will dry within minutes, to produce beautiful surfaces with great brilliance and depth of colour.

▲ 1

▼ 2

Acrylic gel medium
The addition of acrylic gel medium to the paint, which can be mixed in with the colour on the palette using a palette knife, will increase its impasto qualities without increasing its opacity. Its appearance and working qualities may vary from brand to brand, so you should experiment first. It can also be used to extend the paint

ACRYLIC TEXTURE PASTE

For even thicker coloured impastos this more dense medium can be used. It is especially effective for building up surfaces with a palette knife. Also, as a result of its excellent adhesive powers, texture paste can be used to embed other materials such as sand, marble dust or sawdust aggregate to create highly textured surfaces which, when dry, can be sanded, carved or cut, presenting many possibilities for collage work. Ready-made acrylic texture gels are also available for producing a range of textural and impasto effects.

Acrylic and texture paste
Acrylic can be used light on dark as well as dark on light. Here, Moira Huntly shows how she often applies pure, white texture paste over a dark colour (1) and, once this is dry, superimposes a thin glaze of a lighter colour over it. This gathers in the crevices, highlighting the textural effect of the paste (2). Leaving areas of the texture paste unpainted creates highlights, as in her painting Crail Harbour, *while overglazing separate patches of colour with a subtle wash, as here, can pull the surface of a painting together*

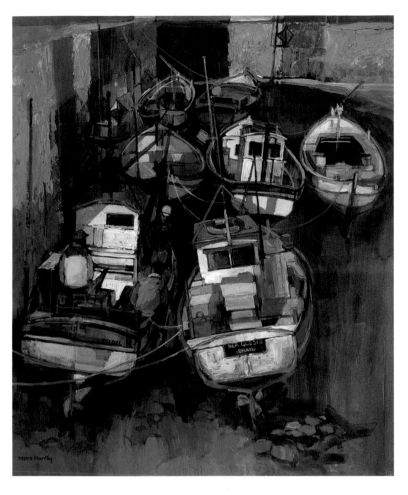

RETARDER

Retarders help to slow down the drying time of acrylics. They come in liquid and gel form. Gel-consistency retarders are the most useful as their structure holds more water, so keeping the paint film open for longer. The addition of a little water will increase their fluidity, although this will also limit their effectiveness. Retarder makes the blending of colours easier but it should not be used excessively as it will form a skin under which the colour will take days to dry completely.

VARNISHES

Varnishing works painted in acrylics will protect their surfaces as well as enhance the brilliance and depth of colours. Water-based gloss and matt acrylic varnishes are available from some manufacturers. A gloss varnish will dry to a flexible, transparent, lightfast and glossy film which is water and scuff-resistant, while a matt acrylic varnish is better for larger works such as murals, as a glossy surface on a large scale will reflect the light unevenly and distort the image for the viewer. Like the water-based gloss varnish, an acrylic matt varnish is also removable. If you prefer a final surface quality somewhere between gloss and matt you can mix the gloss varnish with the matt to form a more satin finish. Either of these varnishes can be removed with an acrylic gloss and matt varnish remover.

Some artists use gloss or matt mediums as a final coating although care must be exercised in these cases that the paint has completely dried and that areas of opaque colour are sufficiently rich in acrylic medium to avoid any smudging.

▲ Creating highlights with texture paste
In this painting on paper,
Crail Harbour
(535 × 440 mm, 21 × 17½ in), Moira Huntly has created highlights and touches of light (see detail below) by adding texture paste and opaque areas of light paint over low-toned, subtle colours

ACRYLIC WATER TENSION BREAKER (Flow Improver)

Hockney's use of detergent in the 1960s to improve the flow of acrylics is now matched by specially formulated water tension breakers. These are simply concentrated solutions of wetting agents which aid the thinning of acrylic colours without reducing the colour strength by the addition of too much water. Water tension breakers allow staining of maximum intensity to be obtained with difficult surfaces such as unprimed canvases. They also improve the ease with which colour can be applied in flat even washes over large areas. This is extremely useful for artists who wish to use acrylics in free-flowing, watercolour-like washes.

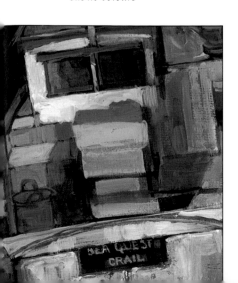

▶ Supports and grounds

Almost any fabric can be used for canvases for acrylic painting. You can use the raw canvas for staining techniques, or you can seal it without obscuring its colour by covering the surface with one of the transparent acrylic mediums, or you may prefer to start with a white ground by applying a layer of acrylic gesso primer, of which there are several different brands available on the market.

Here, you can see the effects of overlaid colour on four different grounds when it is applied, from left to right, to raw untreated cotton duck; cotton duck primed with acrylic gesso primer; raw untreated flax, which is cheaper than cotton duck and has a coarse open weave and warm colour; and flax primed with acrylic gesso primer. The raw canvas soaks up the paint, hence its dark colour; the white acrylic gesso primer gives the paint a brighter, more

transparent quality. To find the support and ground which suits your own work it is best to experiment. When starting with acrylics it may be better to paint on cheaper supports such as paper, canvas boards primed for oil and acrylic, or cardboard or hardboard, both of which can be primed with acrylic gesso primer to achieve a smooth, brilliant white surface ideal for detailed work. In this way you will probably feel more free to experiment, make mistakes and overpaint than when working on a more expensive support

▲ Charcoal and acrylic

In this abstract sketch (915 × 610 mm, 36 × 24 in) based on the natural forms of a close-up view of an overgrown landscape I have combined the broad, linear effects of working with large strips of charcoal, with gesturally applied wet areas of acrylic washes, to suggest the layered, textural effects of an area of undergrowth. Overlaying transparent acrylic paint on top of charcoal in this way fixes the charcoal marks in the paint permanently

▶ Correcting mistakes

Acrylic allows the artist to use opaque overlays of white paint to paint-out areas that have gone wrong, before working back into the painting to redefine mistakes. In Judy Martin's **Self Portrait** *(560 × 420mm, 22 × 16½ in), you can see how the artist is in the process of making changes to the right-hand side of her face and eye by obliterating certain areas with opaque white paint*

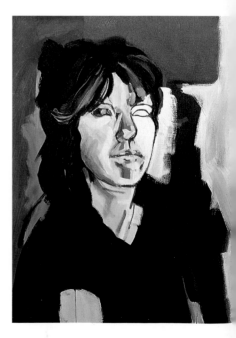

SUPPORTS AND GROUNDS

Almost any surface, including canvas, canvas board, hardboard, card and paper, is suitable for acrylic painting as long as it is clean and oil, wax or grease-free, and it provides an adequate 'key' to which the paint will adhere. You should never size a canvas or any other support with a glue size first, as you must with oil painting, since this will shrink and expand according to the humidity. Acrylics, on the other hand, do not respond in the same way to changing temperatures, and if they are painted over a glue-sized surface the tension between the two layers as the glue size reacts to changing temperatures will lead in time to the paint layers shrinking or expanding and cracking. You should also never use cheaper, ordinary household emulsion paint, or an inferior PVA medium with which to prepare your ground as these are not formulated to be as durable as the products made specifically for fine artists and their use will have an adverse effect on the longevity of your work.

Most artists prepare their grounds by applying an acrylic primer directly onto the raw canvas support. This is often called an acrylic 'gesso' primer, which is misleading since it bears no resemblance to true gesso made from whiting chalk and animal glue and which is semi-absorbent. Basically, an acrylic primer is a mixture of the same acrylic polymer emulsion used as the vehicle for the paints themselves, with Titanium White. In fact if you are going to use the paint in opaque layers and cover the entire surface there is no need to prime the canvas first.

Acrylic primer can be brushed on in one or two coats, or spread on

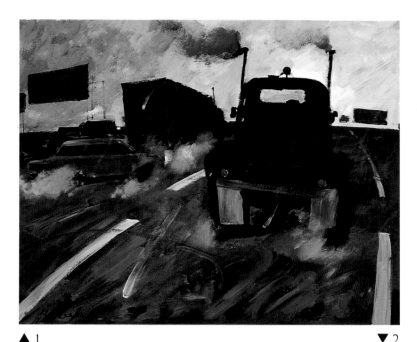

▲ 1

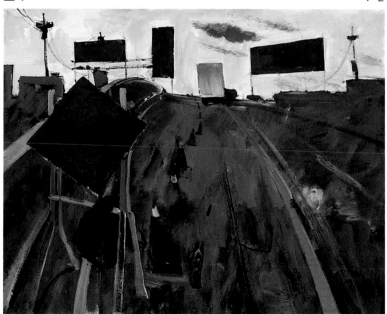

▼ 2

Dry brush effects
A worn-out round bristle brush is ideal for creating dry brush effects with acrylic paint. To create broken colour, similar to the effect that can be achieved with pastels, load some paint onto a dry brush, then brush this out onto a piece of scrap paper to achieve the desired dryness, before rubbing the remaining colour onto your painting. This technique is also useful for creating highlights. In Serge Hollerbach's Turnpike on a Stormy Day (1) *(810 × 1015 mm, 32 × 40 in) he has created the effect of fumes and wet mist, while in his* Left Lane Closed (2) *(810 × 1015 mm, 32 × 40 in) dry brush gives the mottled streakiness of a road surface*

with a spatula or even a clear plastic ruler. The first coat can be thinned with water and will dry in ten to fifteen minutes, after which a further coat can be applied. On very absorbent surfaces a coat of acrylic gloss medium thinned with water and applied before the primer

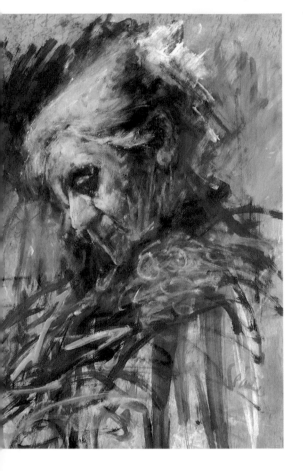

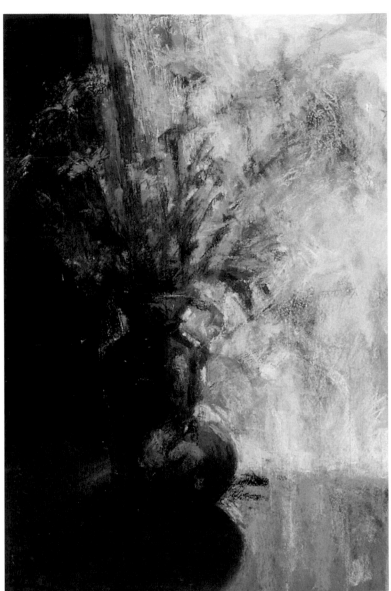

▲ Dry brush drawing
Portrait painter Ken Paine especially enjoys the directness of drawing rapidly with dry acrylic paint, which he applies using a stiff hog brush and a scumbling technique. The dry brush technique contributes to the strength and quality of the drawing in Amelia (455 × 305 mm, 18 × 12 in) *in which he first laid in thin washes of colour before building up the drawing by scrubbing on the colours dry using a worn-down hog brush*

▲ Acrylic and soft pastel
In this mixed media painting, Still Life with Dried Flowers (675 × 445 mm, 26½ × 17½ in), *Debra Manifold was inspired by the dramatic contrast of light and dark tones of objects on a table top, in front of a window flooded with strong sunlight. First she blocked in the main shapes using Yellow Ochre, Burnt Sienna and White acrylic paint onto a roughly acrylic-primed surface. By*

underpainting with loose, bold strokes using fairly thick paint, she built up a substantial textural base that gives body to the picture. She used the brush marks to establish the rhythm and shapes of the flowers before creating the diffusing effect of the light by working pale shades of yellow and blue soft pastel in circular movements over the entire white area, allowing the underlayers to show through in places, before adding dashes of black, blue and sienna pastel

will help to seal the surface; otherwise the binder might sink in, leaving a powdery surface to which subsequent layers of acrylic paint will not adhere.

Acrylic primer provides an extremely stable first layer and makes a suitable ground for both acrylic and oil painting. Many manufacturers offer ready-prepared acrylic-primed canvases for use with both media. The rule that must always be observed, however, is that you must *never* paint with acrylics *over* oils. Oils are greasy and slow drying, and any acrylic layers painted over the top will not adhere properly and in time will crack or even fall off.

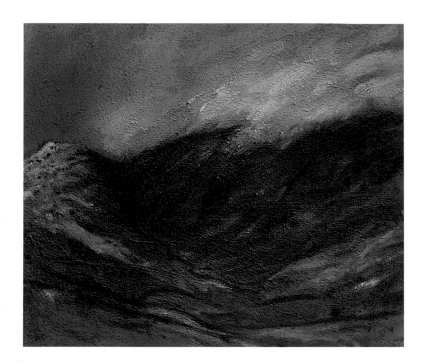

▲ Acrylic and sand
For this moody painting on canvas, Northern Hills *(610 × 760 mm, 24 × 30 in), Brian Yale painted over an initial layer of PVA medium mixed with sand and stained with a colour to create a textured, low-relief surface that effectively captures the gritty texture and rugged feeling of the hills in this landscape scene*

◀ Overlaying transparent glazes
Colours can be built up in thin washes superimposed on top of each other to produce an effect similar to a watercolour. This approach is used on canvas by Leonard Rosoman to develop the luminous qualities and resonance of colour typical of paintings such as The Backdrop, New York *(1270 × 1015 mm, 50 × 40 in). His technique here is to work on specific areas at a time, working colours outwards rather than in 'all over' washes*

▲ 1

▼ 2

▼ 3

Opaque acrylic techniques

In this sequence you can see how Alfred Daniels starts by sketching out the main shapes of a composition onto his acrylic-primed board and lays in a generalized idea of the overall colour areas in warm tones (1) before making a tracing of this key drawing, which he will trace back onto the painting at a later stage. He then adjusts the tones in the scene, lightening the sea, darkening the foreground, clarifying and lightening the main shapes and figures in this area, and redefining the line drawing which is outlined in Burnt Umber with the tip of a No. 2 sable brush (2), having now retraced the original key drawing back onto the painting. The final painting, Fishermen, Hastings *(3) (510 × 610 mm, 20 × 24 in), shows how acrylics are ideal for opaque or 'body colour' techniques in which the opacity of the paint provides colours which can obscure the colour underneath – note how in the final stage the foreground has become much lighter, with no trace of the underneath brown colour of an earlier stage. The clean edges of Alfred's style of painting are well suited to the quick-drying nature of the acrylic medium. The flat, opaque acrylic colours give the picture the look of a gouache painting – the advantage over gouache, though, is that acrylics can be overpainted quickly with no risk of the underlying colours blending or muddying with those on top*

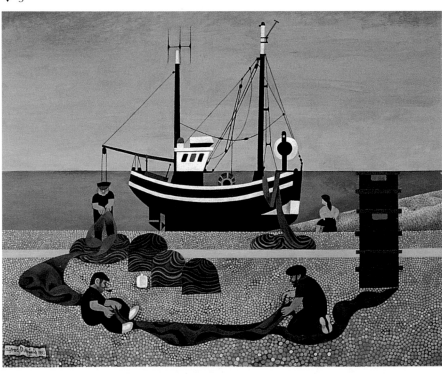

PALETTES

Palettes must be non-porous, so you should use a sheet of glass, melamine, perspex, or any smooth surface from which dried paint can be easily scraped rather than a wooden palette. Expendable palettes such as paper plates are also useful because they can be thrown away. To keep colours moist while in use the palette should be sprayed with water at intervals. Covering a palette with Clingfilm will keep the paints workable for a few hours.

Leonard Rosoman uses a Daler-Rowney Stay Wet Palette, which is designed to keep paints moist and workable for weeks. This consists of a clear-lidded plastic tray, the base of which is lined with a sheet of absorbent paper. This is soaked with water and a sheet of water-permeable paper laid on top, providing through osmosis a mixing surface which stays damp and prevents the paint from drying out. You can, of course, make your own using wet blotting paper and a piece of ordinary greaseproof paper in a shallow tray, which can be covered with a sheet of Clingfilm at the end of a painting session.

BRUSHES

Brushes of all types are suitable for acrylic painting: hog's hair, sables, ox hair, squirrel, nylon; even household painter's brushes for covering large areas. A number of manufacturers also market ranges of brushes made specifically for acrylic painting. The important point is to keep brushes wet while in use and to wash them thoroughly in water afterwards; once acrylic paint has dried it is very difficult to remove.

▶ Stay Wet Palette
Leonard Rosoman transfers his flow-consistency acrylic colours from the 2.25 litre containers in which he purchases them, into smaller, airtight pots, whose lids he marks with an identifying patch of the contained colour. He uses a Stay Wet Palette on which to mix his colours. The plastic cover helps to keep the paints moist and workable

▼ Overlaying colours
Space, colour, rhythm and texture are just some of the visual games that form the basis of this painting, Dance (1370 × 1370 mm, 54 × 54 in), in which the abstract process of painting was the most important aspect. I flooded and stained thin colours into the raw canvas, overlaying other transparent and opaque colours, working wet-into-wet, working back into the painting with white and bleeding colours over some of these areas when the paint was dry, and building up contrasts of texture by adding gel medium and texture paste in places. By playing with the materials in this way, which included squeezing and applying colours straight from the tube, the final abstract image was allowed to emerge

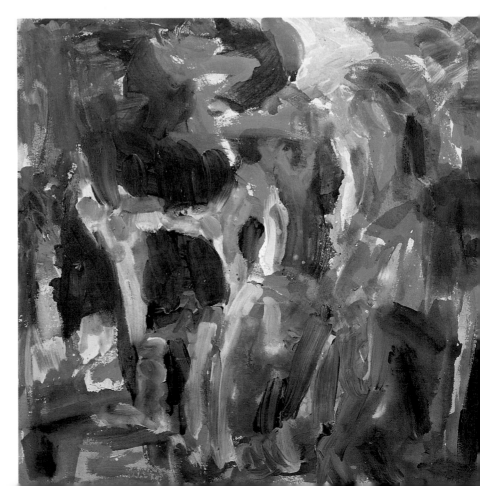

OTHER PAINTING TOOLS

A palette knife can be useful for mixing colour and applying impasto layers to a painting, as well as for scraping through wet paint to achieve sgraffito effects; these can also be achieved with knives, rulers, the end of a brush, the edges of credit cards, or anything with a hard edge or point. Water containers, sponges and clean rags are essential items as are screw-top, airtight jars for storing colours.

EXPLORING ACRYLICS

The rich variety of acrylic work demonstrated by the artists in *Acrylics Masterclass* emphasizes that there is no one 'correct' way to a successful acrylic painting. They all use the medium in different ways, exploring its versatility to achieve a wide range of effects. Enjoy the acrylic medium for its own qualities rather than making it emulate the techniques of oil or watercolours: its use can open up a whole new world of possibilities.

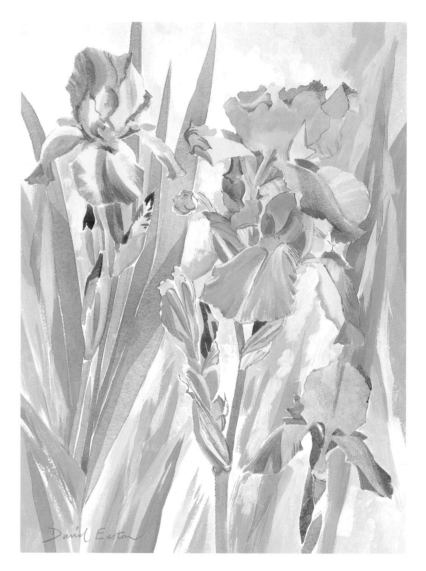

Wet-in-wet transparent and opaque painting
The flowers in David Easton's painting on 140lb NOT *watercolour paper – Yellow Irises (395 × 280 mm, 15½ × 11 in) – were painted first over a light pencil drawing. Here, transparent washes of Azo Yellow (medium and light) were laid in and some touches of Raw Sienna, Quinacridone Violet and Cerulean Blue added while the yellows were still wet. Using the same colours, David adjusted the tones throughout, continuing mainly with transparent paint, before using Naples Yellow, Ultramarine, Hooker's Green and Titanium White to add the background setting and foliage. The technique used on these areas included wet-in-wet opaque painting, followed by glazes of transparent colour*

◀ A detailed approach
David Carter uses acrylics to achieve the degree of sharpness and clarity that he seeks in works such as Winter Fell *(320 × 215 mm, 12¹/₂ × 8¹/₂ in – reproduced courtesy of Major D. B. Bell). He uses CS10 illustration board for his support and builds up individual areas of colour straight onto its brilliant white, smooth surface, diligently accumulating detail by overpainting layer over layer until the desired final effect is achieved.*

He usually starts with the sky, having first defined the mountain tops with masking fluid, before developing the landscape area. Each detail is carefully drawn in, while masking fluid applied with a toothbrush introduces texture into the scene. At various stages the colours in the middle ground or background are 'knocked' back with pale mixtures of white to increase the sense of distance in a technique similar to that used by Martin Taylor in his watercolour landscapes.

Finally, David inspects the painting with a magnifying glass, masking areas with a 2.5 cm (1 in) black square cut out of card, in order to check for, and redefine sharpness and contrast with the use of a scalpel and dark violet paint if he feels it is necessary

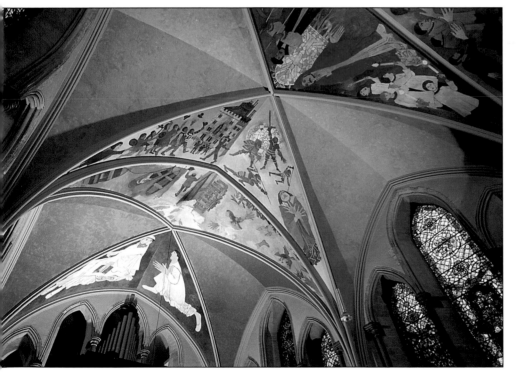

▲ Mural painting
The quick-drying properties and tough final surface quality of acrylics make them ideal for painting on walls. Leonard Rosoman used flow-consistency acrylics to paint directly onto the ceiling of the chapel at Lambeth Palace (reproduced courtesy of the Archbishop of Canterbury and the Church Commissioners)

MASTERCLASS
with Terence Clarke

Terence Clarke works with thinner-consistency acrylic paint essentially because its use allows him to work quickly through a range of ideas without the distracting interruption of the longer drying time of oils. Another advantage for him in using the medium is that his experience with acrylics has contributed to a 'loosening up' of his oil-painting technique.

Essential to his working procedure are the radical adjustments he likes to make to the drawing or colour as a painting develops. These are much more easily and efficiently achieved with acrylics since several layers of the medium can be applied in quick succession and 'mistakes' soon overpainted. It is important for Terence that his working methods remain evident in his finished paintings, hence the tactile quality of his paint surfaces and the textural nature of his brush strokes.

He loves to build up colour harmonies by glazing and modulating the initial hues, while he also appreciates the 'tonal brightness' and 'clean' quality of acrylic colours. As he comments, 'Even rather muddy tones dry into wonderfully bright "clean" greys.' This clarity of colour adds vibrancy to the predominantly bold colour relationships which characterize his work.

▶ Magnolias and Melon
acrylic on canvas
1015 × 810 mm (40 × 32 in)
Terence developed this image out of a landscape painting, which he changed radically by drawing in the still life composition, leaving part of the original landscape to form the view through the window. He has used a great deal of black in this painting, but as a colour value rather than merely as a graphic device to define the edges of the forms. The grey tone of the blind intensifies the whiteness of the flowers, and is repeated in the cloud on the right, linking the foregound with the background. The inclusion of the melon is important for its curvilinear quality in contrast to the strong horizontals and verticals, while its colour gives a bright red key to the painting and strikes a balanced relationship with the red flowers in the vase

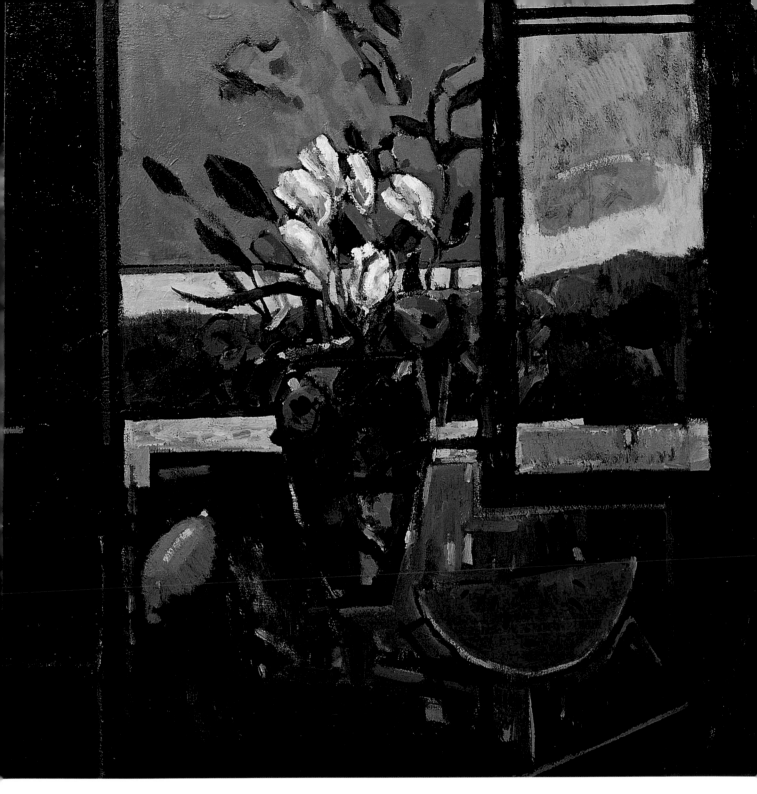

◀ *Terence Clarke*

An Engagement with the Painting

Like other professional artists, Terence recognizes that the key to a successful painting lies in the tension between the subject and the way the paint expresses that subject: 'Anybody can copy something; art is more about creating a quality which is more than the mere representation of what's there.'

He likes to become engaged with his painting as quickly as possible as an object in itself, making its own demands and informing his next moves, sometimes independently of the subject.

For this reason he enjoys working on smooth surfaces like paper, card or hardboard as well as canvas, and building up his paintings in many layers. The advantage of his occasional use of hardboard as a painting surface lies, as he explains, in the fact that 'with hardboard you spend less time disguising the nature of the surface on which you're painting. You can get to a paint quality more quickly and you can kick the paint around, scrape it, wipe it, chuck it on. Hardboard, card or paper are less precious than canvas, which can be a bit inhibiting for inexperienced painters.'

Working Methods

A common practice for Terence when he works on canvas is to start with a white ground which, when dry, he then covers with a thin wash of either a warm, or a cool middle tone against which the rest of the colours will work as they are introduced. On other occasions he might work over the top of another painting which has not worked. Once he has selected the surface on

▲ 1

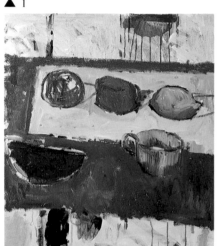
▲ 2

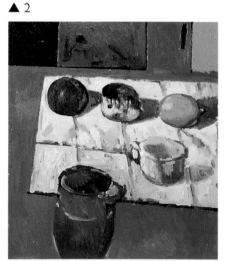
▲ 3

Still Life with Stripes
acrylic on canvas
685 × 585 mm (27 × 23 in)
For this painting Terence chose an arrangement of very simple objects so that he could focus mainly on the formal problems of painting, such as space, shape, colour and tone, and composition.

He started by brushing in the main compositional lines loosely in Ultramarine paint over the top of another, unfinished painting, as a useful alternative to working on a thinly washed coloured ground. Note the initial drawing-in of the melon slice in the middle left, which in subsequent stages disappeared before Terence decided to reintroduce it into the painting later on (1).

The basic elements were next blocked in, again very loosely, and fairly dark layers of underpainting were applied to the objects to establish the broad, tonal structure of the composition (2).

As he began to work into the objects Terence decided to replace the melon with the jug in order to break up the foreground and introduce a slightly more ambiguous spatial arrangement. The blocking in of the top half of the composition now helps to contain the picture, while it also heightens the colour values throughout the rest of the painting (3).

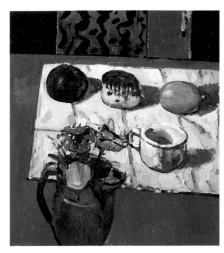

▲ 4

▲ 5

Next, Terence blocked in the flowers, made the painting of the cup more definite, and worked further on the background before stopping to consider what adjustments to make to improve the overall composition (4).

After a great deal of looking and thinking, and in spite of its finished quality, he decided to change the position of the lemon by drawing boldly into the picture using a brush loaded with Ultramarine paint to move it higher up the table top (5).

To disguise this radical alteration, he used liberal amounts of paint, especially in the area where he needed to re-establish the presence of the white cloth, occupied previously by the original lemon. The new position of the

lemon has now broken up the previous symmetry of the top part of the painting, while its intensified colour creates a greater impact. Another important change at this stage is the addition of the left-hand edge of the table, which helps to balance the painting; it also adds a dynamic quality (6).

Finally, Terence felt compelled to make some even more radical adjustments. So, in one painting session lasting about three hours, he extended the cloth, painted out the jug and reintroduced the original melon, added the blue striped material, eliminated the scone and reincluded the apple which had made a brief appearance in the bottom part of the first stage. He also completely reworked the background and

gave the table a bottom edge.

The finished painting now bears little resemblance to its earlier stages, but the false starts, mistakes, and radical changes have played a crucial role in the final result. They are the key, in fact, to the vitality of Terence's final images (7)

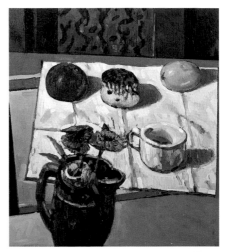

▲ 6 ▼ 7

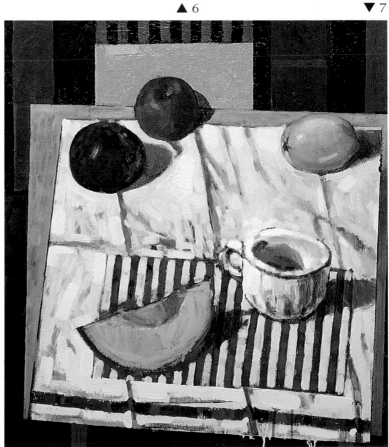

which he wants to develop a particular painting, he draws in the subject and blocks in broad, structural areas of colour to define the composition. At this stage he is finding his way into a painting. In both his landscapes and still lifes Terence will respond to the way the painting looks, as well as the subject, as a work develops. This means that the actual space sometimes becomes distorted or rearranged – as in *View from Lickey Hills* and *Magnolias and Melon*.

Using thin, translucent glazes he allows the underpainting to inform the colours worked over the top and he is quick to exploit any interesting accidents that might occur.

He thinks in terms of the composition as a whole, playing colours off against each other across the entire surface, reinforcing the dark tones to balance the lights as the painting develops. At all times he works quickly, wet-into-wet, using hog hair brushes of various shapes and sizes, Chinese brushes, sometimes a palette knife, and finally sables for smaller, finer lines and touches. The speed at which he works at each stage is essential to keeping the work fresh and alive. This dynamic quality is also enhanced in his still lifes by the fact that he takes a high viewpoint and illuminates his subject with an angle-poise lamp.

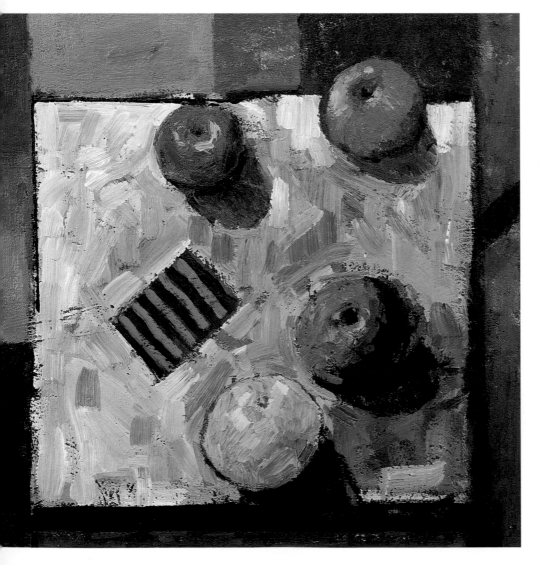

Still Life with Grapefruit
acrylic on canvas
510 × 510 mm (20 × 20 in)
This image was painted quickly and with great abandon over the top of a painting that was not working. Almost in desperation Terence put some fruit on the studio table from which to work in order to give himself fresh impetus. He used masses of paint, working into areas that were still wet from previously applied layers; his main concern at this stage was to get rid of the original composition. The final image took only about an hour for him to complete.

The single line of blue at the bottom of the painting acts as a visual foil to the warm ochres and brownish tones throughout the rest of the composition. Note, too, the lively, sculptural, quality of the paint marks describing the objects and table top, compared with the more smoothly painted blocks of colour framing this central arrangement

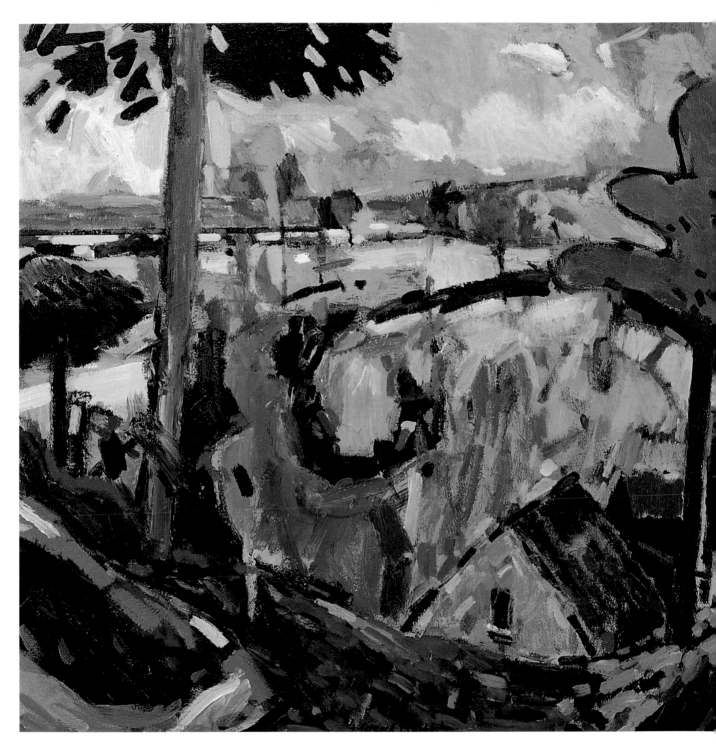

View from Lickey Hills
acrylic on canvas
915 × 915 mm (36 × 36 in)
Based on on-the-spot drawings
of, and notes about this view,
there is nevertheless very little
topographical accuracy in this
final image.

To start, Terence applied a
pinkish ground, before blocking
in the basic compositional
drawing with black paint.
Then, working quickly, he
developed a lively orchestration
of colours by introducing
dramatic tonal contrasts,

interweaving these to work
with and against the
background pink. The liberal
and free application of the
paint, as he developed and
altered the painting over several
weeks, gives the painting its
lively surface energy

MAINTAINING THE SPONTANEITY

As a painting develops he keeps an open mind about its progress so that he is free to respond to its demands, often changing direction and making radical compositional changes. This may mean changing the position of certain objects, altering colour values, adjusting shapes, painting out areas that do not work well within the design and even introducing new objects. The melon in *Magnolias and Melon*, for example, was only included late in the painting's development. Its strong red colour and curved shape are important elements for balancing the darker colours and the overall vertical and horizontal structure of the whole composition.

The courage to make such changes allows for a certain freedom and spontaneity of approach. However, Terence makes the point that, 'The problem for many inexperienced painters is that they work too slowly and not spontaneously enough.' He believes that it is important not to expect to get a painting right first time: 'A large part of the process is the painting out of certain areas to find out where you go next.' For this reason he encourages inexperienced painters – and beginners especially – to use acrylics, 'because painting with them is not as much of a commitment as it is with oils; you can change things so rapidly.'

DRAWING INTO PAINTING

Another typical problem for inexperienced painters, which the use of acrylics can help to overcome, is the tendency to start with a subject, fill up the picture surface with details and then not really know

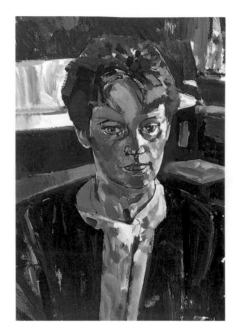

Portrait of Mary
acrylic on paper
810 × 585 mm (32 × 23 in)
Painted from life, this monochrome portrait shows how useful acrylic paint can be for making purely tonal studies, and for practising drawing back into a composition. Here, Terence has used a full range of tones, from the black in the folds of the girl's coat, to the touch of pure white on the side of her nose

how to develop the painting any further. As Terence points out, 'They can't get to the next stage, which is to get the whole surface going again. With acrylics you can "collapse" a painting and bring it back, thus producing a far richer surface in terms of paint quality and colour harmonies.'

The grisaille technique – of which *Portrait of Mary* is a good example – is a useful exercise for getting used to this process of collapsing and reworking a painting. It means drawing with black and white tonal mixtures of acrylic paint and learning how to model with brush marks and tone rather than looking only for lines with which to describe a subject. As Terence emphasizes, 'It's a good way of teaching people how to draw for painting. It gets you used to the process of getting things going again; blocking in the subject, then once the acrylic paint is dry, drawing back into it with the brush. This is what many inexperienced painters don't do.' The important thing to learn here is the freedom to lose yourself in a painting and not

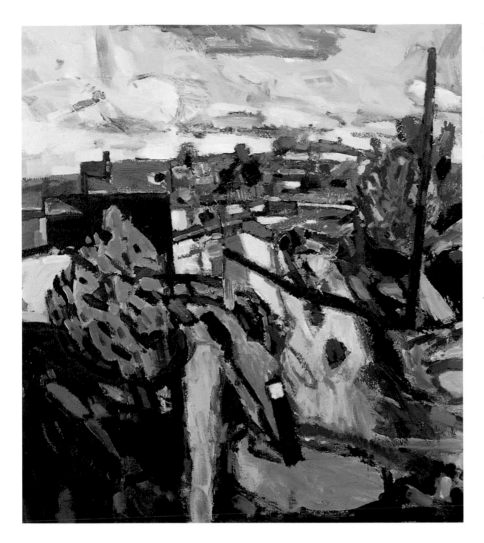

The Black Post
acrylic on canvas
965 × 760 mm (38 × 30 in)
Terence used a couple of rough sketches of some broken-down buildings as the starting point for this painting, in which much of the foreground has been invented and the space distorted to give the subject greater visual impact. The casual, painterly quality of the sky is the keynote to the rest of the painting and, although far from naturalistic, the tonal values of the colour relationships help to make the image work as a harmonious composition. Much of this work was done using a rapid wet-into-wet painting technique

to be too intimidated to make changes. Acrylics are ideal in this respect because you can make changes with them and work back into a painting with confidence.

Drawing, in fact, is the fundamental element which underpins and informs Terence's painting technique. He draws almost every day to keep his hand and eye in tune – either outside in the landscape, from a life model, sculpture, or other objects which catch his interest. As for most good artists drawing for him is the rehearsal for his painting. He believes strongly that most people's technical problems with painting originate from their lack of drawing practice. As he explains: 'It gets you used to seeing

relationships; if you draw regularly you will be able to compose instinctively.' Confidence about your drawing gives you the 'freedom to change things to get the relationships in a painting right'.

THE IMPORTANCE OF THE SUBJECT

Terence paints traditional subjects such as landscape and still life in order to use the relationships he sees as the basis for creating compositions dominated by the free use of bold colour. He looks essentially for the underlying structure of a subject – whether it is a still life or a landscape – and seeks to identify

and translate the main abstract shapes into a broad compositional design of shape, tone and colour. Here, the advantage of still life as a subject lies in the opportunity it affords to impose your own structure on a painting. Additionally, a still life does not move about, so you can keep coming back to it, making it, as Terence says, 'the best subject for an inexperienced painter to start with'.

He collects objects which have shapes or colours that attract him, and sets up arrangements which are interesting for their variety of pattern and challenging spatial relationships. But although occasionally he is more faithful to direct observation in some of his still lifes than he is in most of his landscape paintings, in others, particularly *Still Life with Pizza*, for example, he likes to distort perspective and dovetail unrelated bits of space together to set up a new pictorial reality. It is important for Terence that with all his subjects he is able to interplay observation with what he refers to as the artist's 'poetic licence'. Ultimately, for him the subject is the vehicle for his enjoyment of the abstract elements of painting.

COLOUR AS TONE

Terence exercises 'poetic licence' in his use of bold, exaggerated colour. He uses bright, pure colours and a surprisingly limited palette comprising Ultramarine, Cadmium Yellow, Permanent Rose, Monestial Green, Titanium White and Black. A small amount of Cerulean is sometimes useful on its own as an accent, while a touch of Cadmium Red is used when he wants an area of pure, bright red. Black is important as a colour in its

own right. He never uses it to tone down other colours; instead he uses it to enhance the vibrance of other colours – note, for example, its effectiveness in heightening the brightness of the colour relationships in *Magnolias and Melon*.

Like most experienced artists Terence thinks of colour and tone as interrelated elements; many paintings depend for their success on the judicious control of tone, which in his case he transposes into bold colour. 'If you use tone correctly, you can get away with almost anything. You can brighten colour as long as the tonal relationships are right.' He abandons realistic colour in order to create impact and compositional drama. The organization of colour, especially in his landscapes, relates back to the abstract arrangement of shapes suggested by his subject matter, although its placement is not necessarily relevant to the creation of a sense of space. He might, for instance, use the most vibrant and brightest red in the most distant areas in a painting and blues in the nearest planes – as in *View from Lickey Hills*. Colour in Terence's paintings is allowed to function as a powerfully sensuous element. In his work you can see how the use of

▶ Still Life with Pizza
acrylic on canvas
760 × 760 mm (30 × 30 in)
The upturned, flattened table top and sense of looking down on the objects in this painting, emphasizes Terence's delight in exploring unusual spatial arrangements on a flat surface. Here, some of the spatial arrangements, for example those between the small jug and fruit in the top half of the picture, work fairly convincingly, while in general the spatial relationships make sense only within the overall compositional design.

The stark whiteness of the tablecloth is enlivened by the creamy pinks, yellows and blues showing through the underlying touches of paint, while the jug and pieces of fruit add warm highlights to an otherwise cool painting

◀ *Terence finds large plastic bottles of liquid-consistency acrylic colours more economical and convenient to use than buttery-consistency tube colours, especially as he uses such large quantities of paint. Large ice cream tubs filled with water are used for washing his brushes, which range from hog's hair ones of various shapes, Chinese brushes, and sables for smaller, fine marks. He also uses a palette knife*

non-representational colour can give ordinary objects and landscapes a new impact.

Terence builds up his orchestration of hues on the premise that there is an optimum amount of any one colour that you can use in a particular painting. And his work shows that even when the range is tightly restricted it is important to balance the tension and activity derived from oppositions of tone and hue by the addition of accents, or by making subtle changes.

COMPLEX ABSTRACTIONS

The balance between discord and harmony, the sense that 'everything holds together' is just one of the issues Terence enjoys in painting. Crucially, it is the *process* of painting which motivates him above all. He advises that painters should 'paint for the experience of painting rather than the result. Sometimes you do something you're pleased with, but you soon need to get back to the experience of the activity.'

MASTERCLASS
with Peter Folkes

For Peter Folkes acrylics are the best medium for producing landscape and townscape paintings in a method similar to the Old Masters' technique of glazing layers of colour to build and control a painting. He delights in the physicality of making paintings – of putting paint on a surface – and allowing the work to 'speak back' to him. The subject is the excuse for this enjoyment and gives him the basic structure from which to develop a painting by exploring shape, colour and tone and surface texture. His more imaginative subjects – the cow paintings especially – allow him even greater freedom to enjoy the potential offered by the use of acrylic paints. Indeed he exploits the medium to its full potential through a huge variety of techniques and different subject matter to achieve an enormous range of effects.

Compared with most of the other *Acrylics Masterclass* artists Peter's work is fairly monochromatic in colour. He avoids using bright hues because he feels that he has never been good at handling strong colour. Instead he concentrates on chiselling out three-dimensional space in his pictures through subtle tonal contrasts. You can also see that he echoes particular colours throughout the various elements of a composition to give it a sense of unity.

▶ Red My Coat and Red the Blood They Spilled
acrylic on paper
510 × 340 mm (20 × 13½ in)
The photographic transfer technique was used to produce this work in which Peter intends the painted area to represent the reality of the uniform, and the transferred magazine photographs the images of memories associated with it. The result is a painting in which the ideas suggested by its combination of photographic and painted images dominate the formal qualities of the composition

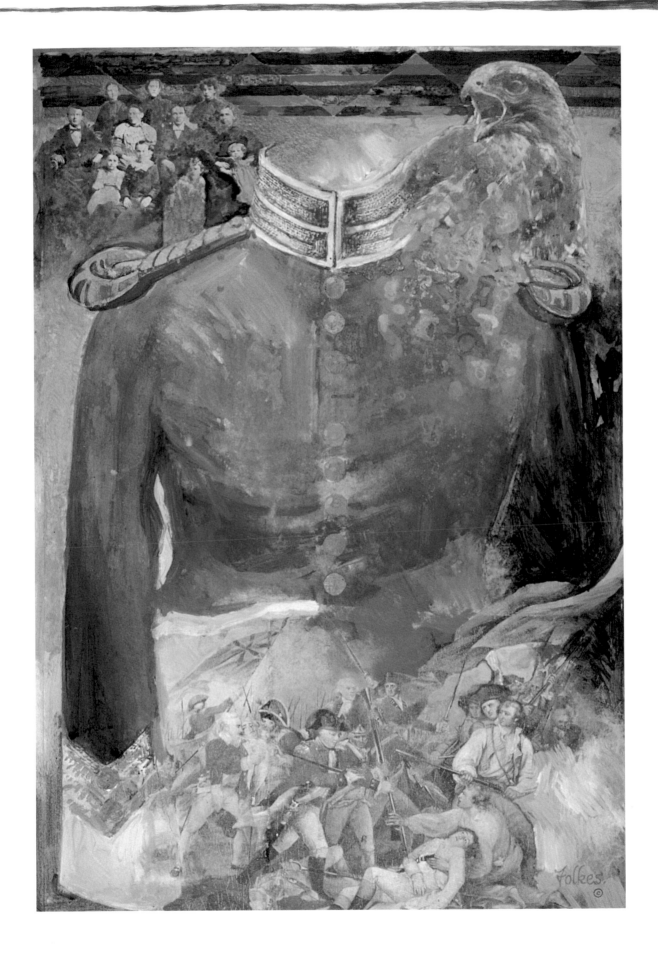

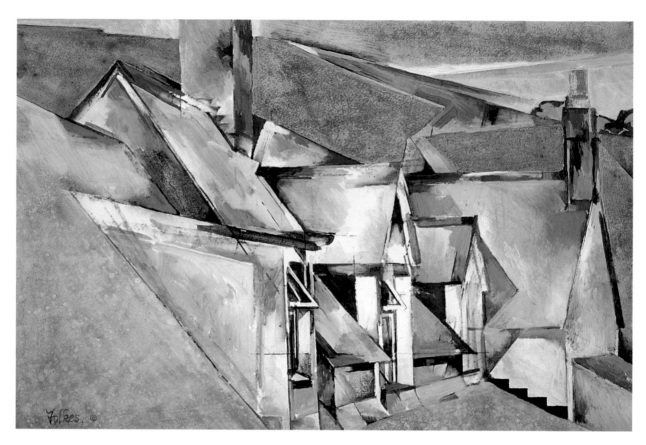

Roof of the Hand Hotel, Llanarmon
acrylic on paper
355 × 510 mm (14 × 20 in)
This painting is typical of Peter's interest in the angular structure of buildings and rooftops. Here, he deliberately varied the light source to enhance the geometric structure of the painting. The fine straight lines were achieved by applying paint to the edge of a ruler and printing this directly onto the painting

SELECTING THE SUBJECT

Peter insists that you must always select subjects which tie in with whatever you enjoy about painting: 'You must pick a subject that is appropriate to, and from which you can extract the kind of formal things that you enjoy about the process of making a painting.' He is keenly aware that painting is about finding the right balance between interpreting what you see and treating the painting as a thing in itself, with its own inherent qualities.

With this in mind the subject is chosen according to how it can help him to structure a painting; it must suggest the arrangement of flat shapes from which he can build the illusion of space on his painting surface. To help him to distil these essential elements he draws from the subject in charcoal or pencil in his sketchbook, picking out the shapes, angles and lines that relate to the rectangle of his picture, using these as the initial framework – bearing in mind all the time the importance of his picture shape. With landscapes this means that a sharp right angle in the subject is critical because it relates directly to the edges of the painting. It also explains why he enjoys painting buildings; the straight lines and right angles in the subject relate quite naturally to the rectangle of the painting, as in *Roof of the Hand Hotel, Llanarmon*, for example.

Light and atmosphere do not interest him as much and in the end the painting will not necessarily bear a great similarity to the initial subject. He emphasizes the importance of being prepared to make changes to allow the painting to grow and develop, describing this as 'changing *to* the image; not away from it'.

Full Was My Life,
Empty My Death
acrylic on canvas
760 × 610 mm (30 × 24 in)
On canvas Peter often, as here,
starts by developing different
rough and smooth areas in the
priming so that interesting
things begin to happen as soon
as he applies his first layers of
paint. Use of the photographic
transfer technique and scraps
of mirror-plastic added as
collage help to contribute a
mysterious dream-like quality
to the painting

As a change from the 'hard work' of starting and developing a painting from the compositional ideas inspired by an observed subject, Peter also likes to start from an imaginative idea, as in his cow paintings and *Red My Coat and Red the Blood They Spilled*. Making compositions from his imagination allows him greater freedom to enjoy the techniques possible with acrylic painting and is 'a kind of relaxation; a more fun activity'.

COLOUR AND TONE

For each painting Peter first decides what colours he wants to use, more often than not taking his cue from the subject. He invariably squeezes out Burnt Umber, Raw Umber, Raw Sienna and White onto his palette, to which he might then add Phthalo or French Ultramarine Blue; Payne's Grey; and Olive or Phthalo Green and any additional colours according to his subject. He never uses pre-mixed greens straight from the tube, preferring always to mix these with other colours.

Ultimately, though, it is clear from Peter's paintings that colour does not excite him as much as the challenge of getting the right structure of shapes within the boundaries of his composition, or indeed his love of texture.

THE SUPPORT

When painting on paper Peter likes to work on a Not or hot-pressed surface which he primes with a thin coat of acrylic gesso primer. A fairly smooth surface is important for him as he likes to build up textures with the paint rather than have the texture of the paper dictate the result.

On canvas, as in paintings like *Full Was My Life, Empty My Death*, he applies his own primer made from a measure of zinc oxide combined with a measure of Polyfilla mixed with a little water to make a thick paste before adding a measure of an acrylic medium. With the composition of the picture firmly in mind he primes parts of the canvas thickly and roughly using a palette knife, while other areas are primed thinly with a brush. When this is dry he part sands down the thick priming to allow hollows and crevices to remain in the sanded surface. Experimenting at this stage and creating different areas of rough and smooth surface on one canvas means that exciting things begin to

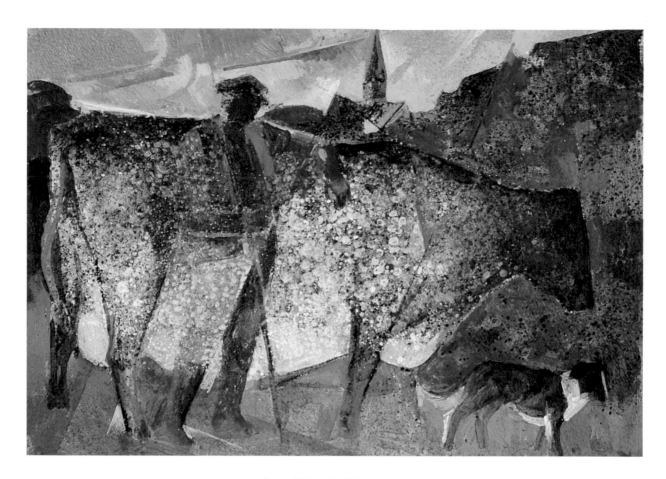

Cow, Church, Herdsman
and Dog
acrylic on paper
255 × 355 mm (10 × 14 in)
*A compromise between the
subject and a two-dimensional
abstract design has evolved in
this painting. A spattered base
was applied over the whole
surface before Peter began to
develop the composition.
Extensive use of glazes of
different greens, allowing the
underpainting to show through
in many areas, gives the
painting its luminous quality*

happen as soon as he applies his
first colours. By scumbling the
colour deep into the textured sur-
face and then wiping the wet paint
from the raised areas – leaving
colour in the recesses – the tactile
texture of the priming is revealed,
enlivening his painting surfaces.

BLOTTING AND GLAZING

Lively surface texture characterizes
two of his works on paper especial-
ly: in *Cow, Church, Herdsman and
Dog* and *The Last to be Milked* the
texture of the cows, which adds a
special character to these images, is
the result of his 'blotting' technique.
To achieve their speckled, textured
appearance he begins by 'scrib-
bling' acrylic paint on fairly hap-
hazardly, before 'blotting' it with
newspaper. Peter then spatters

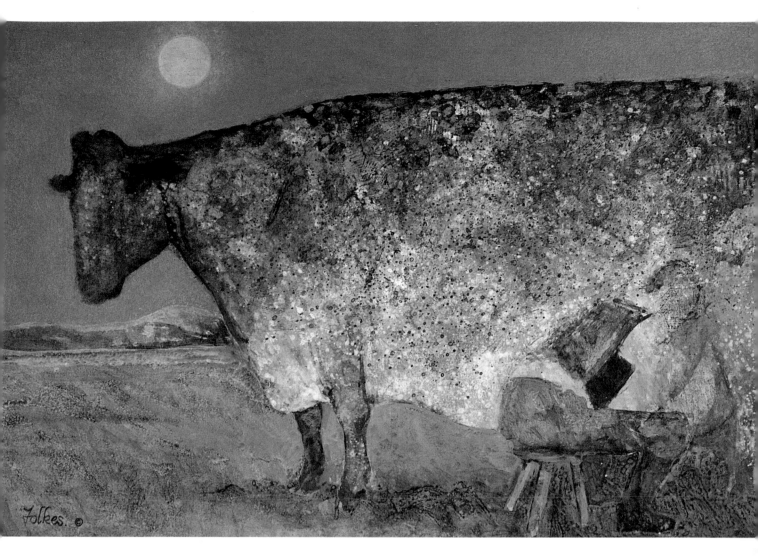

another colour over the top and allows this to part-dry before washing it down: by this method the wet areas of paint come away to reveal the white priming underneath, while the dry areas remain. As he explains: 'Lovely little circles are made by blotting part-dry spatters which are still wet in the middle.' He continues to spatter and blot part-dry paint in this way until he has developed the surface texture to his satisfaction. This technique is unique to the acrylic medium and shows how accidents can be exploited and controlled to play an effective role in a painting.

In his paintings from an observed subject he often adopts techniques

The Last to be Milked
acrylic on paper
355 × 510 mm (14 × 20 in)
Imaginative paintings in which cows feature prominently give Peter an ideal excuse for exploring the textural possibilities offered by the use of the acrylic medium. The lively textured pattern along the cow's back in this painting was achieved by repeated spattering with browns and greens. The warm glow of the sky was developed by underpainting this area first with copper and silver metallic paint before stippling over it with a semi-covering coat of blue-green paint

47

of the Old Masters by applying thin transparent glazes of one colour after another to produce optical colour mixtures. This additive glazing progressively darkens the painting but by using semi-opaque thin white paint scumbled over selected areas Peter is able to lighten tones again in preparation for further glazing. Note his use of this technique in *Semer Water from the Askrigg Road.*

An important point to remember here is that most paints change in colour when mixed with white to lighten the tone value, so the artist must decide whether to achieve a light tone by adding white or by diluting with water. If Peter wants a pale raw umber in a particular area, for example, rather than mix White with Raw Umber on his palette, he first paints the area white and waits for it to dry before overpainting a glaze of Raw Umber and, if desired, blotting this second layer of colour when it is part-dry. If this colour requires further modification he might add a further glaze of blue, and so on until he is satisfied. The great advantage with the quick-drying quality of acrylics is, of course, that you can carry on building up glazes and scumbles of colour in this way very quickly. As Peter notes: 'You can rapidly build, control and change a painting by alternating between glazes and scumbles. If you want to produce a naturalistic painting, there's no better way of doing it.'

DEVELOPING THE PAINTING

For his landscape and townscape subjects Peter begins by drafting out the main structure of a composition in charcoal on his prepared support, after which all kinds of brushes and implements are used to apply his

▲ 1 ▼ 2

Semer Water from the
Askrigg Road
acrylic on paper
(340 × 445 mm, 13½ × 17½ in)
In the sketchbook drawing in
charcoal and graphite pencil,
made on location in Yorkshire,
Peter noted the basic details –
including many distortions
and much simplification –
required for developing a
painting back in the studio (1).
Using the sketch as his guide
he drafted out the main
directions of the composition in
charcoal and then in paint on
140lb HP watercolour paper,
which he had previously
stretched and primed with one
coat of acrylic gesso primer (2).

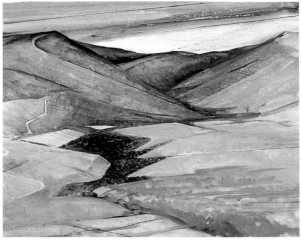

▲ 3 ▲ 4 ▼ 5

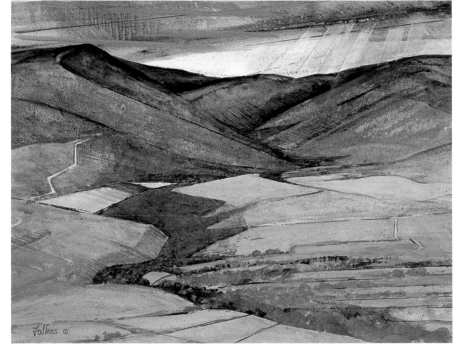

Folkes ©

Large areas of paint were broadly applied with a rag. Some of these were spattered with water before being part-dried with a hairdryer. The spattered areas take longer to dry than the base paint, so that when the part-dry area is washed down with water, the wet splatters are removed, leaving the dry parts. This technique breaks up flat areas of colour into more interesting surface effects. Peter then covered the remaining unpainted areas with thin paint which he blotted to give a simple texture.

Peter also added structure lines relating to the rectangle of the picture by printing colour onto the painting with the edge of a ruler, while contours were developed with the edge of a one stroke brush (3).

Using a print roller, he added warm brown paint to the near hills while trees were suggested by adding dark greens in the middle distance and blues and mauves in the background. Next, Peter turned his attention to the near fields in an aim to make the foreground come closer without weakening the strength of the hills in the far distance (4).

Dissatisfied with the painting, he decided to add sun rays to the sky to make an angular link with the lines of the landscape, and to work on the hills again by applying glazes of blue-violet and different browns, which he interspersed with numerous blottings with newspaper and by washing down half-dry paint. To prepare for the final colour glazing he painted out the fields with white, tinted with Raw Sienna..

The fields were then glazed with a little transparent green. The river valley was developed to echo the fan of the hills and the fan of the sun rays. Other minor adjustments to help bring unity to the composition at this final stage included the lightening of the tone of the dark trees to stop this area from dominating the composition visually (5)

acrylic colours. Peter explains that, 'Because speed is all-important you need to give yourself time by finding ways of achieving the effects you want.' At the start of a painting he often fills in large areas of colour with a rag. Then, to substantiate the straight and angular lines in the composition, he may apply paint to the edge of a ruler and press it down in the chosen place to make a fine broken line. For finer linear work Peter sometimes uses a ruling pen filled with liquid paint.

Linear marks are critical for helping to create a sense of space in Peter's work. These are sometimes also achieved by dipping the edges of credit cards into his paint and pressing these onto his paintings to make short, angled lines. Trees might be suggested by stencilling paint through a piece of perforated zinc; while surface texture and pattern are achieved in a similar way to the method used in his imaginative works by blotting part-dry paint with newspaper, cartridge or blotting paper for different effects. Sometimes he presses paint across the surface using a printing roller to achieve a broken distribution of colour; he might also spatter paint onto the surface with a toothbrush.

As well as a wide range of brushes he also uses his fingers, a palette knife, bits of hessian. As a result during its development the painting naturally becomes a more complex surface of shape, colour, tone, line and texture as he seeks equivalents in paint for the structure and mood of his subject.

In the latter stages of development the painting simply 'comes to an end' for him. He tries to resist the temptation to 'tidy things up', although he is not afraid to destroy things if he feels he has taken something too far.

ADDITIONAL MEDIUMS

Peter takes full advantage of the available acrylic additives to assist his working methods. He uses matt medium rather than water to thin his paints, which accounts for the 'lustre' finish typical of his paint surfaces. He finds retarder useful, especially for painting large areas such as skies, where he often wants to be able to blot the colour once the whole area has been covered and before it dries completely. Water tension breaker is also valuable for helping him to spread paint over large areas. Finally, if he is painting on canvas he gives the finished work a coat of matt acrylic varnish to protect its surface from the atmosphere. This also makes the painting impervious to water.

THE PHOTOGRAPHIC DRY TRANSFER TECHNIQUE

In addition he uses gloss medium to transfer photographic magazine images in reverse onto some paintings. In *Red My Coat and Red the Blood They Spilled* you can see that the images at the top and bottom of the painting have been transferred from actual reproduced photographs. To achieve this effect the selected photographic image is first completely covered with a smooth layer of white acrylic paint and allowed to dry. The back of the image is then sand-papered to remove the surface ink to allow an even soak through of water. The area on the painting where the image is going to go – which must have a layer of dry acrylic paint already applied – is covered with a layer of gloss medium. The image is then placed, white acrylic side down, onto the gloss medium,

▶ Chalk Track on the Tidworth Downs
acrylic on paper
340 × 510 mm (13½ × 20 in)
The forms in this undulating landscape scene have been deliberately distorted to exaggerate the dramatic sweep of the hills. Our eyes are led across the rolling countryside and into the distance by the curving and angular lines extending from the foreground into the background, while the diagonal lines in the sky balance this basic compositional structure and help to contain the composition within the small rectangle of the paper. Spattering and printing techniques were used here, and in some areas paint has been stencilled through perforated zinc to create lively textures which imply the presence of trees. Peter used a fan brush for the receding lines across the field in the foreground

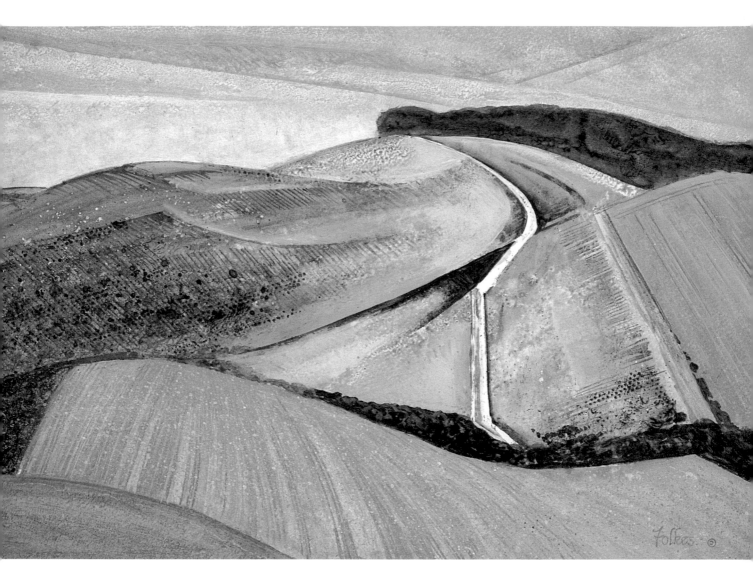

while it is still tacky, and pressed into place using a lino roller.

With the introduction of water the acrylic films swell; then, by applying heat they become sticky and bond together when pressure is applied with the lino roller. Once this is thoroughly dry Peter starts to wear away the backing paper using just a little water, but not allowing this to soak the films again. This is dried and repeated five or six times until the paper has been removed completely, leaving the printed image on the painting. Often you then need to add a wash of yellow to the image to replace the yellow printed ink which also tends to

come away during this process. To integrate the edges of the photo-graphic image with the painting Peter stipples appropriate colours all the way around with an old shaving brush.

A New Vocabulary

It is clear from Peter's range of sub-jects and experimentation with a variety of techniques that for him acrylics open the door to a whole vocabulary of textural opportunities which can be exploited to maxi-mum effect in both naturalistic and imaginative paintings.

MASTERCLASS
with William Hook

William Hook's paintings are a celebration of the dramatic effects of light. In selecting his subjects he looks for the way strong light defines the shapes and colours in a composition. In effect the subject provides him with the compositional design through which to express the mood of a place as it is affected by the light, weather and indigenous culture of an area. Open landscapes under huge skies, seascapes and regions where the quality of light is a recognized feature of their character attract him, although he also works on still lifes in which he again focuses on the compositional opportunities afforded by the colouring of the light. You see in his work his constant concern to express these light effects through his use of high key, although naturalistic, colour. By emphasizing contrasting light and dark hues – shadows versus brilliantly spotlit areas – he enhances the vibrancy of his colours and creates the impression that the paintings are actually transmitting their own, sparkling light.

William finds that acrylics are the ideal medium for achieving these vibrant light effects and colours; their translucency, clarity and intensity, especially over his bright white grounds, are perfect characteristics which he exploits to brilliant effect in his handling of the medium.

▶ Daisy Field
acrylic on canvas
455 × 610 mm (18 × 24 in)
This painting in which the yellow shapes of the daisies twist and turn and weave their way towards the background wall and gate has a wonderful spontaneity about it which results partly from the speed at which it was painted – it took William only three hours to complete. It combines flamboyant brushwork, thick paint, and wet blending of colours in the middle and background, suggesting distance, with more definite shapes in the foreground.

The painting is characterized by the predominance of the yellows and greens, which are nevertheless relieved by the horizontal brown strip of the fence and the occasional flecks of purple and red-orange wild flowers. The white highlights, added by quickly brushing white paint through the wet paint of the green leaves so that they partially blend and trail off as they diminish, also help to enliven the limited range of colours used in this painting

PHOTOGRAPHY AND DRAWING

Light effects are naturally transient and for this reason William finds the camera a 'wonderfully useful' sketching tool. He uses photography to capture fleeting light conditions and also to help him to decide on his compositions, using the lens like a viewfinder. Photography is such an important source for him that he might take up to ten or more colour transparencies of a subject, using various exposure settings to ensure that he achieves at least one accurate record of the colours in a scene. This also allows him to study the subject from many different angles while the light is static, and to focus on close-up details. In fact he insists that the best way to learn about composition is through the camera lens: 'It helps your eye to recognize a design – to see the wonderful compositions that already exist in nature.' But he warns against the pitfalls of using photography too literally, not least because, as he says, 'The distortions in perspective and colour are not believable in painting.'

William works from his colour transparencies direct by displaying them in a slide viewer. In this way he can distil information from a selection of images, or reduce a composition to its basic essentials and from the start interpret, rather than simply recreate, the photographed subject on his canvas. His aim is to make a painting with a vitality of its own; he is not interested in projecting an image onto his support and repeating it, which for him is 'not a viable way to learn'. As he explains: 'The subject creates a mood, a feeling, which I try to realize in paint.' No photograph would have quite the same effect of a painting such as *Autumn Fields*

Photographic studies for Trailhead
Sometimes, William takes information from more than one colour transparency and combines this to produce a completely new, composite painting. Here, the photographic view of the canyon (1) was used extensively for the overall structural shapes of the composition of the painting, although William added the foreground shrubbery from memory. He reversed the photographic image of the rider and mule (2) in the painting to make them appear to be going down the trail, and to lead the viewer's eye into the painting

▲ 1 ▼ 2

(page 61), where the smooth, brightly painted rooftops contrast with the texture and natural colours of the harvested fields and the foreground bushes, weeds and rough ground. In the brushwork, the dramatic viewpoint, the bold colour and contrasting tones, the personality and enthusiastic response of the artist to his subject are clearly evident.

Sometimes William combines information captured on colour transparencies from several different

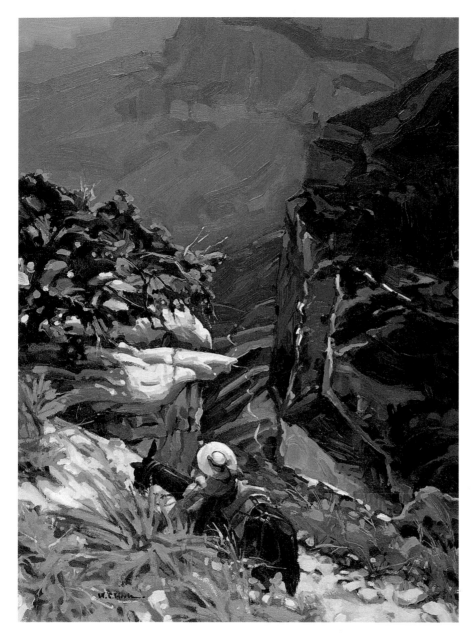

Trailhead
acrylic on canvas
610 × 455 mm (24 × 18 in)
As in Autumn Fields *(page 61) the sense of distance is emphasized in this painting by the contrast with the middle and background of the century plant in the lower left foreground, which does not appear in the two photographic images from which* Trailhead *has been composed; its addition here strengthens the whole composition.*

The variety of broad, directional brush strokes helps to describe and differentiate between the natural shapes and forms, while William also used the corner of a size 8 brush to add the tapering lines of the trail in the middle ground. In some places he has scratched through wet paint to indicate some of the smaller branches of the trees, and in the shrubbery in the foreground to the right of the rider, revealing the white of the gesso underpainting

views to produce a composite painting which becomes something completely new. For *Trailhead,* for example, he used two photographic views of a Grand Canyon pass to make this composite painting in which we look down on a rider and mule making their way down a narrow path, beyond which the deepness of the gorge has been emphasized by his manipulation of its perspective and tone.

Although William's compositions are basically defined through the camera lens in this way, drawing is also important for him; whether sketching on the spot or from his slides onto the canvas, he works freely and with an awareness that drawing is fundamental to the success of his finished paintings. He enjoys how a line defines contours, form and structure, and believes that you must strive always to understand the function of drawing, even in your painting.

The way in which William organizes his painting environment is important to his working methods. To be able to paint with controlled spontaneity, he needs to move easily from work surface to palette to canvas. Having everything in a familiar place eliminates the possiblity of mistakes: his paints are laid out in a familiar order; brushes are kept in two containers and separated by size – Nos. 1 to 6 in one, and 7 to 12 in the other. The slide viewer on which he displays his photographic references stands to the right of his easel

THE PAINTING SURFACE

The support on which William likes to work is usually a pre-stretched canvas primed with gesso, although sometimes he works on canvas board. The canvas surface must have a medium texture; in many instances in the later stages of a painting William likes to allow this texture to show through areas of paint to break.up solid colours. This textured ground is important for helping to create dry brush effects – a technique in which acrylic paint is applied with a dry brush so that the underlying colour is modulated by the broken colour on top as it picks up the irregularities of the textured surface. This effect is similar to the effects typical of working with pastels over glasspaper.

The clean, white brilliance of the ground is vital to the final vibrancy of William's paintings. In view of this he often applies another coat of bright white gesso to a commercially prepared canvas.

DEVELOPING THE COMPOSITION

Once the composition is sketched out onto his canvas in water-soluble pastel pencil, large areas of colour, such as skies that require graduating from the top down to the horizon line, are painted in quickly. For these areas William finds it useful to spray water onto the canvas with a spray bottle to keep the area damp and more receptive to applications of paint. This also makes it easier to soften and blend colours. He warns against spraying over painted areas, however, as this can affect the colours already applied.

Working in manageable sections is vital to William's method of painting; by doing so he is able to blend his colours in the early stages while the paint is still wet. The major shapes in the composition are mostly defined in these early stages by the establishment first of the dark tones, for practical reasons working from right to left across the canvas: being left-handed he likes to make sure that he does not smudge the wet paint with his hand. He continues to develop the painting by working from dark to light, often adding varying amounts of white to the stronger colours to create the lighter values, before applying the highlights in the later stages of the painting.

EXPLOITING THE MEDIUM

As the painting develops he enjoys the way in which textured areas build up naturally as he overpaints areas of initial, often thickly applied colour with additional impasto layers. The importance behind overpainting lies in the opportunity it gives him to redefine his first shapes, soften edges and modify his colours. He points out that it is far better when the paint has dried to the point of being tacky and stiff to change things by overpainting, rather than attempt to rework freshly applied paint because, 'once acrylic paint starts to dry and reaches that point of no return, when the paint has just started to set, a brush stroke will not cleanly pass over or through the paint that has already been laid down'.

He encourages students new to acrylics to understand and work with their inherent qualities in this way, and to see their quick-drying nature as an advantage. The fact that they dry rapidly means that you can make changes very quickly and

Seashore
acrylic on canvas
510 × 510 mm (20 × 20 in)
This painting from a
photograph taken in Italy on a
cloudy day conveys a more
subtle, atmospheric effect than
the other paintings shown here.
The areas of sky and water
were both developed quickly
using thick, buttery paint,
to allow the painterly
manipulation and easy blending
of colours and to suggest the
more fluid effects of moving
clouds and water.

 Seashore demonstrates that
a light atmospheric airiness,
softened clouds, water
reflections and clear but muted
colours are all effects that are
achievable using techniques
which are in tune with the
qualities of the medium

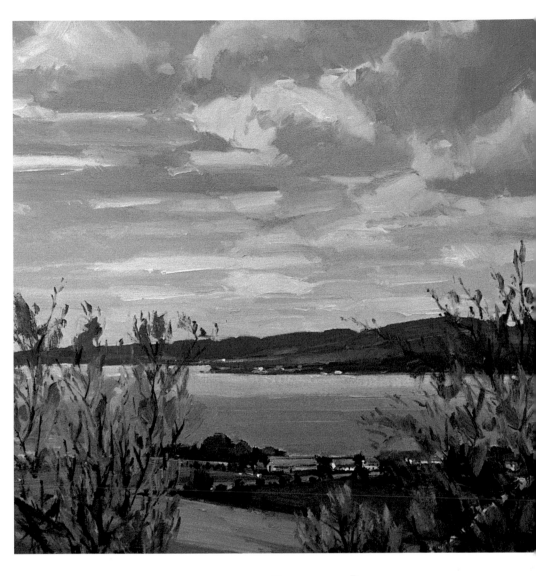

if, like William, you are an impa-
tient painter, it also means that you
can maintain the spontaneity and
enthusiasm necessary to finish a
painting from start to finish in one
go, which he likes to do.

 As an additional word of encour-
agement to people new to acrylics
William adds: 'Experiment with
acrylics – use them in a soft man-
ner, in a very deliberate manner
and the way in which I like to use
them best: in a painterly style, using
built-up paint. I like to use every
aspect and every limitation of the
medium to the full. The best
achievements come from experi-
menting with the medium.'

EXPRESSIVE BRUSHWORK

William insists that brushwork is
every bit as important to the final
success of a painting as the light
effects, colour and composition.
He also notes that it helps to avoid
the tendency of many inexperi-
enced painters to overwork a paint-
ing. As he says: 'The thickness of
the paint and the direction of the
brushwork can describe the shapes
and forms of nature; can free up a
painting. You can adjust the hues
or make a work more comfortable
with skilful brushwork. The secret
is not to overwork it; not to make it
look laboured.'

▲ 1

▼ 2

Forest Scene
acrylic on canvas
1015 × 915 mm (40 × 36 in)
After sketching out the basic shapes with a water-soluble pastel pencil, William plans his painting carefully by deciding how to break the work into sections small enough to allow him to mix and apply the paint while the area is still wet, and by assessing how much of which colours he will need for an organized and efficient painting session. Here, he begins by blocking in some of the dominant vertical elements of the tree trunks (1).

Next, he adds contrasting colours, beginning with the verticals, before establishing the dark greens of the left-hand tree. By applying the colours in thick, buttery strokes, William is able to blend the paint easily as it remains wet in this state for longer than when it is applied thinly. The foreground is developed using large brush strokes and thick paint. By working quickly, but with a controlled spontaneity, William starts to establish the painterly

effects that he likes to achieve in his work (2).

The addition of some of the darks of the distant evergreens behind the aspen trees starts to give more definition to the foreground shapes, while he also now begins to work from the darks to the lights in the area of the tree foliage; here, the darker yellowy greens are a mixture of Yellow Oxide, Permanent Green Light and Medium Magenta; the lighter yellows are Yellow Oxide mixed with Cadmium Orange (3).

He prefers to use synthetic brushes because the paint stays on the outside of a synthetic brush and transfers liberally to the canvas rather than loading up inside the brush. 'Flat' brushes and 'brights', which are shorter and more stiff than flats, allow him to make very definite, deliberate brush strokes – he never uses rounds. He mostly uses a No. 1, 7, 8, 12 and occasionally a No. 20 size brush. He emphasizes that you should avoid using small brushes so that you are not tempted to get too involved in fussy detailed work: 'Using the edges and corners of the brush is particularly important and keeps us all, no matter how experienced, from becoming too dependent on small brushes for small detail.'

He advises students to experiment with the strokes used to apply thick paint in order to discover the wide range of effects possible: 'A bold stroke will push paint up on the outside edges of the brush when done with force. When lightly drawn over the canvas, the stroke puts down a thick layer of paint.'

Brushwork is important for William for creating the illusion of

▲ 3

▼ 4

Starting here with the first of several layers of the intense blue of the sky colour at the top of the painting, William begins to suggest the bright light and humidity of the scene through the strong contrast of the blue with the yellows of the backlit leaves of the trees. Painting in the sky at this stage also allows him to define the shapes of the branches and twigs and to begin to soften any hard edges that are not required (4).

William's brushwork is critical for suggesting the different tensions and qualities of the various elements in a scene. The broad strokes used for the leaves and foliage give way at this stage to the thin, delicate, rhythmic lines of the branches and twigs, forming an interlocking pattern which moves the eye across and through the mass of yellows and greens of the foliage. A lighter version of the sky colour added further down in the painting helps to give more positive definition to the foreground shapes. By extensively overpainting the left-hand tree, the darker-leaved areas of the foliage, and the base of the tree trunks, William builds up heavy impasto areas which contrast with the translucent quality of the highlit yellow leaves. The final use of the dry brush technique to add a brighter green to the extreme foreground brings up the colour of the grasses and helps to balance the brightness of the blue sky at the top of the painting (5)

detail and for expressing the different tensions in a subject. In *Forest Scene* sketchy, imprecise strokes applied with the edges and corners of brushes suggest the delicacy of the smallest branches and twigs of the aspen trees and delicate foreground grasses, and contrast with the broad strokes in the trunks, leaves and foliage to create a dramatic visual tension. Such spontaneous, expressive brushwork combined with more delicate areas helps William to recreate the random quality of the natural world and its wealth of contrasts.

▶5

Bent Street Still Life
acrylic on canvas
610×610 mm (24×24 in)
William liked the triangular arrangement of the table in relation to the pots and flowers and the way in which the shadows cast by the late afternoon sunlight made the legs of the green table a dominant element in this scene. The painting has been kept comparatively uncomplicated by his use of broad, simplified brush strokes and by his deliberate avoidance of trying to describe the various elements – especially the flowers – in more detail.

The shadowed areas of the green table were painted first to establish the basic shapes created by the strong light effects; the other elements were then painted around this, gradually defining shapes and highlights in the process.

William used the dry brush technique to suggest the difference in texture of the pots and gate leaning against the wall from the table and foliage, both of which he developed by adding colours while the paint was still wet. The leaves on the flagstone were added at the end with loose, dry brushwork

COLOUR INTERACTIONS

William knows that to use colour effectively you must be aware of how juxtapositions of colour can deceive the eye; he is keenly aware that a red placed next to a blue will make the blue appear more green, for example. He uses these colour interactions to describe the forms in his composition and, of course, to create the illusion of light.

His description of light involves emphasizing strong tonal contrasts. These, in turn, enhance the vibrancy of the hues. In this way colour shifts and moves the eye through the patterns of shapes created by the light that defines form and depth. Notice, for example, how in *Bent Street Still Life* your eye is guided from the green leaves at the top of the painting, through the table legs and to the green of the potted plant leaves, the colour of which is enhanced by the red and yellow flowers, creating a dramatic and sparkling effect. The narrow range of colours comprising red, yellow, blue, green and white, used in direct tonal oppositions, demonstrates the effectiveness of working with a limited palette. Strong definition is given to this composition by the interplay of light and dark, warm and cool colours.

William's palette consists of Titanium White, Hooker's Green, Burnt Sienna, Yellow Oxide, Medium Magenta, Permanent Green Light and Dioxazine Purple, to which he occasionally adds Cadmium Orange, Cadmium Yellow Medium, Ultramarine, Cadmium Red Light, Naphthol Crimson and Phthalocyanine Green. Clarity of colour is paramount. He works on the premise that you should observe and understand the colours in your subject and break them down visually before you attempt to paint them. He aims to mix the correct colour before applying the paint to the canvas although, of course, you can modify colours once they have dried by overpainting with another colour using a dry brush. Notice how in the foreground of *Forest Scene* the broken brighter green on top enlivens the more subtle olive colour underneath.

A CONCENTRATED STUDY

In trying to penetrate the mysteries and drama of natural forms and shapes as they are illuminated by strong light, William has evolved a style through which he delights in the full range of techniques possible with acrylics. He says: 'Painting is a fierce, concentrated study. I plan how to attack a canvas, and I try to be constantly aware of what technique to apply to best effect. For example, mixing paints next to each other to find the right hue or altering colour with dry brush to pick up on irregularities: these things require total concentration.' Ultimately, though, he points out that once you have learned to work with the medium, 'the enjoyment to be found in acrylic painting is long-lasting'.

Autumn Fields
acrylic on canvas
1015 × 760 mm (40 × 30 in)
Documenting the changing landscape environment is important to William. This 300-year-old sheep farming community in northern New Mexico intrigued him because of the contrasts between the different colours and shapes of the rooftops and fields.

The simple contrast in size between the foreground plants and bushes and the smaller shapes of the buildings, and the aerial perspective of the purple-blue background mountains emphasizes the

sense of receding distance.

A large brush was used to lay in the broader areas of the colours of the fields with thin paint; by using the corner of the same brush William also defined the roof shapes. Finally, by rapidly twisting his wrist, he made quick and simple marks to indicate the shadows and windows, again using the same brush. The dry brush technique was used in this painting to help create the suggestion of the texture in the fields and foreground shrubbery, and to suggest the highlights with white on some of the rooftops

MASTERCLASS
with Moira Huntly

Moira Huntly adopts a flexible approach to her materials and techniques. She has used buttery-consistency acrylics since the 1960s, alongside her work in watercolour, oils, gouache, pastel, ink and a variety of drawing media. Compared with these other media the versatility of acrylic paint is of particular importance to her: it allows her to start with thin, translucent glazes, build up layers of colour and pattern in creamy impasto, followed by much heavier textures with the addition of acrylic texture paste to the paint, and return finally to thin washes and glazes – all within the same painting. Her technique of glazing one brilliant colour over another adds a wonderful vibrancy to these often complex images. She also finds acrylics especially useful for her mixed media work because of their adhesive and fast-drying qualities.

The key to Moira's work lies in the tension between a realistic interpretation of her subject matter and the distillation into a two-dimensional design on her picture surface of the basic shapes and intervals between them. In effect she forgets what it is she is looking at and instead looks for shapes and how they fit together and make a pattern.

Moira is attracted to subjects which have a vertical emphasis – buildings and townscapes, industrial scenes, boats with the vertical lines of their masts, harbour scenes and still life especially. Her overriding interest is in the interlocking pattern of simple angular shapes, straight lines and curved forms which she 'extracts' from her subject.

▶ White Flowers and Ginger Jar
acrylic on canvas
610 × 760 mm (24 × 30 in)
A group of some of Moira's favourite objects has been translated in this painting into an almost two-dimensional pattern of light and dark geometric shapes, based on rectangles, squares, circles and semi-circles. The mirror placed behind has contributed to this effect by setting up an additional series of reflected abstract shapes, which Moira has interwoven with the shapes of the actual objects depicted in this arrangement.

The interweaving of foreground and background space is complemented in this work by the interplay across the surface of thin and thick paint, and dark and light tones. The lightest and also the thickest areas were built up with texture paste, and later overlaid with thin glazes of vivid reds, ochres and yellows – a method which has contributed in an important way to the overall vibrancy of the colours

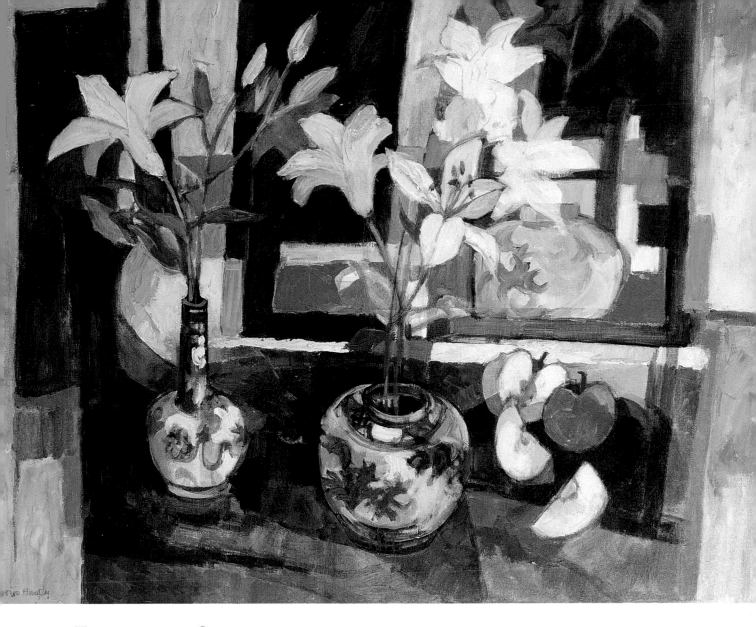

TRANSLATING THE SUBJECT

Everything in Moira's subject matter becomes translated into these abstract patterns and relationships. In this respect still life is a particularly useful subject because you can, as Moira points out, 'impose your own arrangement' on the composition and enjoy exploring and developing the elements in it that most interest you. In order to focus on the pattern of positive and negative shapes in her still lifes she will often adopt a high viewpoint, which helps to flatten the space and allows you to see the spaces between shapes more clearly. In addition a mirror, carefully placed behind a group of objects, can help to set up a repeated pattern of real and reflected abstract shapes 'which becomes almost abstract'. A high viewpoint and the use of a mirror were both adopted in *White Flowers and Ginger Jar* to help Moira focus on developing the rhythmic interweaving of flat, colourful shapes and flattened space typical of this painting.

COMPOSITE PAINTINGS

As with her materials and techniques Moira takes a variety of different approaches to developing her finished paintings. Many of her compositions are developed entirely imaginatively from a variety of separate sketches. The advantage in doing this for the inexperienced painter especially, is that it frees you from the inhibitions of sticking too closely to a realistic description of the subject. By making composite paintings from several different drawings you can, as Moira notes, 'make your own adjustments to the composition away from the subject. You've got the option to decide what to do with the information you've gleaned from drawing on the spot; you don't have to stick to it too rigidly.'

For these composite paintings Moira often uses sketchbook drawings from many years ago: 'I often go back and look through early work with a fresh eye and see things in it I can use today.' The idea for the *London Underground* composition, for example, came from some old pen and ink sketches done on the Underground stations in the 1950s: the closed space, rectangular shapes, decorative archways, texture of the brickwork, all appealed to her present interest in the complexity of shapes and textures inherent in this urban scene.

MATERIALS AND TECHNIQUES

When she sees a subject Moira instinctively knows what medium, or mixture of media, she will use to develop a composition. She does not have a set method of approach to her work and will choose to use acrylics when she knows she wants

▲ 1

▲ 2

Studies for London Underground
Moira often finds it useful to explore compositional ideas in collages and tonal drawings before starting a painting.

The organization of these cut-out monochrome paper shapes is based on the major shapes and rhythms of an on-the-spot sketchbook drawing of the Underground done in the 1950s. They were *shifted and juggled around considerably before Moira pasted them down in this arrangement on a sheet of paper using acrylic matt medium (1).*

In order to take the idea further and establish the most satisfactory composition Moira drew from the collage in charcoal on paper, redefining the shapes, their spatial arrangement, and the tonal structure of the picture (2)

London Underground
collage, acrylic and charcoal on paper

380 × 510 mm (15 × 20 in)
When Moira was happy with the information developed in the charcoal drawing she reintroduced realistic elements into the abstract arrangement of shapes by including definite objects such as the poster on the pillar behind and to the left of the foreground figure, and the figures themselves.

In this final work, retained areas of soft charcoal drawing contrast with flat areas of acrylic colour; in other areas the charcoal drawing shows through thin washes of acrylic colour glazed over the top

to build up a painting quickly and develop textural effects by combining translucent glazes, impasto and heavier textures in one image.

Her supports vary from ready-prepared medium-textured canvas, watercolour board and mounting board, to 140lb, smooth surface, hot-pressed watercolour paper – all of which provide her with reasonably firm surfaces on which to work. A smooth surface is always preferable to her as it is better than a heavy textured ground for achieving the 'bubbling' and glazing effects that she enjoys about working with acrylics.

At the start of a painting she applies thin, diluted washes of acrylic paint with housepainter's brushes, to establish the general

shapes of the composition and the main colours. One advantage with acrylics at this stage for Moira is that by using the colour thinly the brush marks are retained, creating interesting, vibrant effects from the outset. To exploit these effects more effectively she thins her colours with matt medium; when this combination is applied vigorously to the surface the paint bubbles and blobs, creating a 'frothy' texture.

For skies or water Moira often uses a 'wash-out' technique. This means flooding wet washes of thinned colour over the top of another wet wash of colour; which causes the colour underneath to lift and bleed with the top colour, creating an interestingly mottled, stained effect.

▲ 1

Winter Harbour

acrylic on canvas
610 × 915 mm (24 × 36 in)
Moira amalgamated several
on-the-spot sketches to create
this composition, which in its
monochromatic interplay of
cool blues and greens, suggests
a dark, wintry atmosphere.

Initially she established the
general composition and key colours by broadly brushing
on thin washes of Monestial
Green and Ultramarine Blue,
working wet-into-wet to give a
lively background from which
to develop the painting. By
leaving some areas of the
canvas free of paint she was
later able to exploit these
lightest tones to suggest strong
touches of light (1).

Darker toned areas of wash
were then introduced, after
which Moira superimposed the
mass of horizontal, vertical
and diagonal construction
lines of masts and buildings to
form the compositional
'scaffolding' of the painting. At
this stage her concern was to
get the abstract design right:
the spaces between the boats,
the relationship of the masts to
the edge of the canvas, the
balance and echo of the
rectangular shapes along the
waterfront with the rectangular
shapes of the boats (2).

As the painting developed,
broadly applied, diluted
transparent washes gave way
to thicker, more opaque paint
and the introduction of small
areas of related colours such as
olive green, turquoise and
purples. The heavy, thickly
painted sky contains the
colours used throughout the
rest of the painting, providing
a sympathetic balance to the
solid shapes and dark tonal
key of the harbour scene (3)

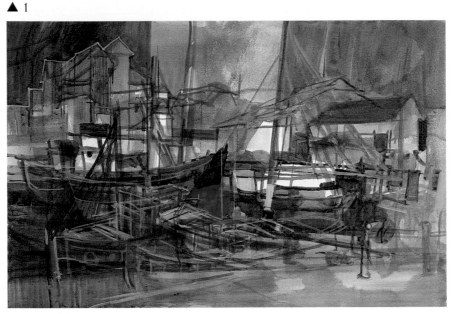

▲ 2

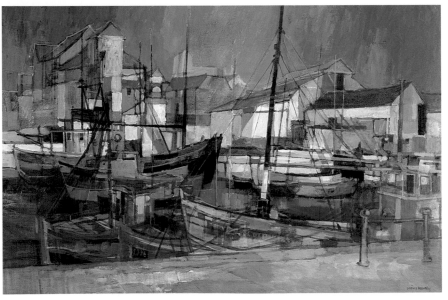

▲ 3

DEVELOPING THE PAINTING

As a painting develops, super-imposed transparent glazes give way to applications of thicker, more opaque paint, applied with soft synthetic or watercolour brushes – compare the quality of the finished surface of *Winter Harbour* with its earlier stages, for example. In some works Moira introduces more heavy, impasto layers by applying texture paste with a palette knife. The lightest areas in *White Flowers and Ginger Jar* have been built up in this way and later overlaid with thin glazes of reds, ochres and yellows; while in *Overy Staithes, Norfolk*, the addition of texture paste on the buildings, washed over with thin glazes of warm colour, helps to create the effect of sparkling light and adds to the overall surface texture of the painting.

The effect of Moira's working procedure is that her work naturally becomes more and more complicated as she develops a composition, until the entire surface is alive with pictorial activity: 'Every part of the picture is a painting in itself; I like to have something good going on in every area.' This is partly why everything in her subject comes forward, and is the reason why she adopts a close-up viewpoint, because it allows her to concentrate on the surface qualities of her paintings. A notable feature of *London Underground*, for example, is that your eye remains focused on its texture, colour and surface pattern.

Overy Staithes, Norfolk
acrylic on board
510 × 585 mm (20 × 23 in)
In contrast to Moira's other work, this composition was painted on grey Ingres board, starting with broad transparent washes of acrylic brushed on in blocks of colour to indicate the general shapes of the buildings, trees, boats and water.

Finer brushes were used to define these elements further, after which Moira established the darker tones, followed by the building up of thicker layers of more opaque paint and impasto with the introduction of texture paste. The tonal brightness of the texture paste in contrast to the darker colours in the rest of the painting helps to create the effect of sparkling light, especially on the walls of some of the buildings and the end of the middle foreground boat

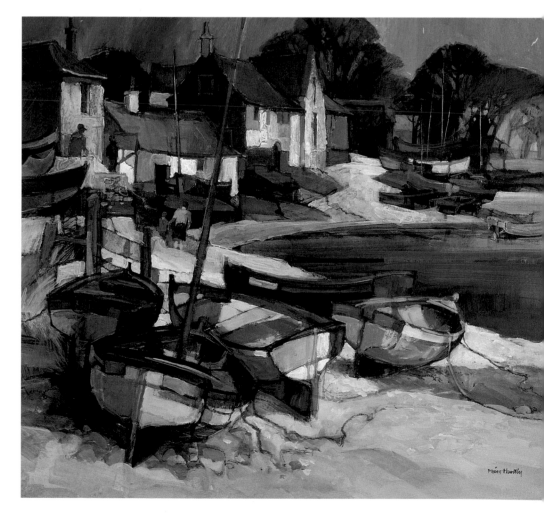

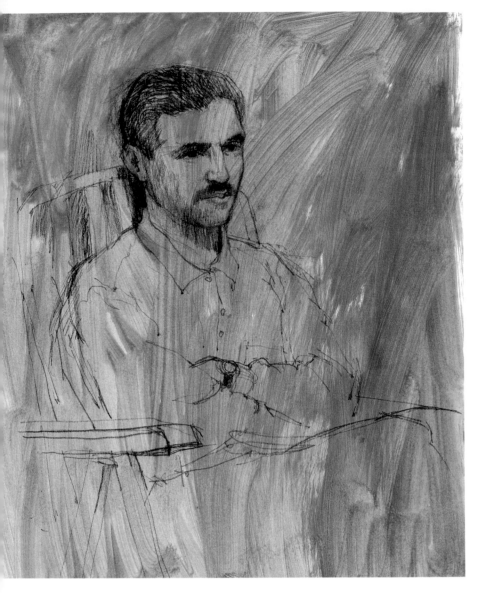

Haytham
*acrylic and charcoal pencil
on paper
470 × 380 mm (18½ × 15 in)
This study shows how a thin
background wash of acrylic
colour, applied to a sheet of
paper in broad gestural strokes
with a housepainter's brush,
can give an interesting vitality
to a portrait, drawn here in
charcoal pencil*

occur during the development of a
work, and to make changes in rela-
tion to the entire composition and
its particular intention: 'One diffi-
culty is when you've got an area
you're pleased with and is working
well, yet you realize it isn't working
with the painting as a whole – to
destroy the pleasing area takes a bit
of courage, but usually it's the only
way to put a painting right.'

DRAWING ON COLOURED GROUNDS

For her portraits Moira often starts
by brushing a thin acrylic wash
onto a fairly heavy pastel paper or
mounting board to create an inter-
esting coloured ground, before
drawing in charcoal or pencil over
the top, as in *Haytham*. This idea
originates from her interest in
Leonardo da Vinci's method of
drawing on top of a coloured
ground and clearly demonstrates
how she loves to handle and mix
different media, and explore the
properties and artistic potential of
her materials. It also reveals her
enthusiasm for finding modern
equivalents for the techniques of
the great masters.

MAKING CHANGES

During the development of a paint-
ing Moira remains open-minded to
making whatever changes a compo-
sition might demand. Not having
the courage to do this is a problem
that particularly afflicts inexperi-
enced painters, who often cannot
accept the idea of losing an area of
the composition that may be work-
ing well in itself, but which does
not contribute to the unity of the
whole. This comes with practice
and experience, which enable the
artist to cope with events as they

MIXED MEDIA

Moira often decides to use mixed
media when her work has come to
a standstill, her ideas have dried up
and she feels in need of stimulation.
The advantage of using mixed
media is that it offers the potential
to make new discoveries, develop
fresh ideas, and increase awareness
of tone, colour and texture. As she
says: 'If you've done a series of
paintings in one particular medium
you get a bit stale; experimenting

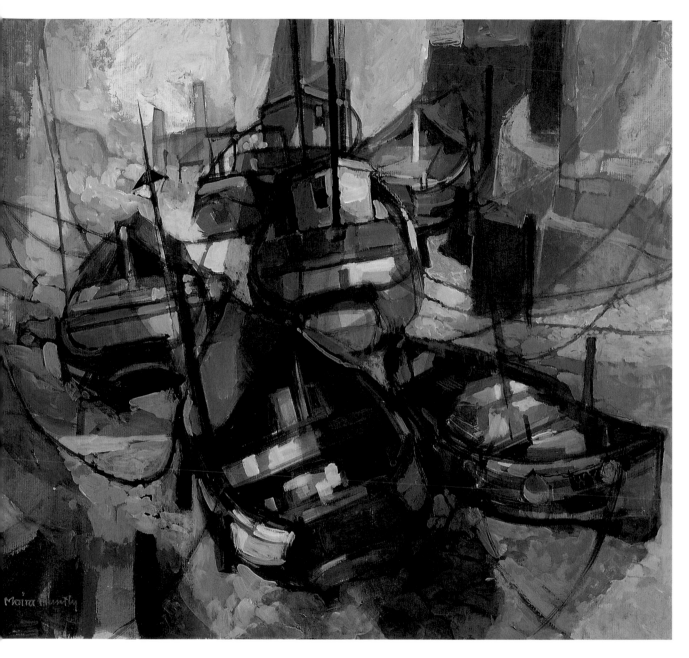

with mixed media leads you on a step – something can happen unexpectedly and give you a lift – it's also good to make full use of accidents that may occur.'

Acrylics are especially useful for mixed media techniques because you can apply them to so many different surfaces – as long as they are grease free. One particular advantage of using acrylics for collage work is that the excellent adhesive qualities of the acrylic matt medium

Fishing Boats, North Yorkshire
acrylic on board
380 × 430 mm (15 × 17 in)
The jumble of boats in this painting on hardboard forms an almost abstract pattern; the curvilinear lines of the ropes echo the curved shapes of the boats and help to link all the elements in the composition. But Moira's principal interest in this work is in the interplay

of the colour relationships between the cool blues and soft warm yellows. The subtle green-greys, yellow-greys and blue-greys throughout the painting help to interlink these two dramatic contrasts of tone

69

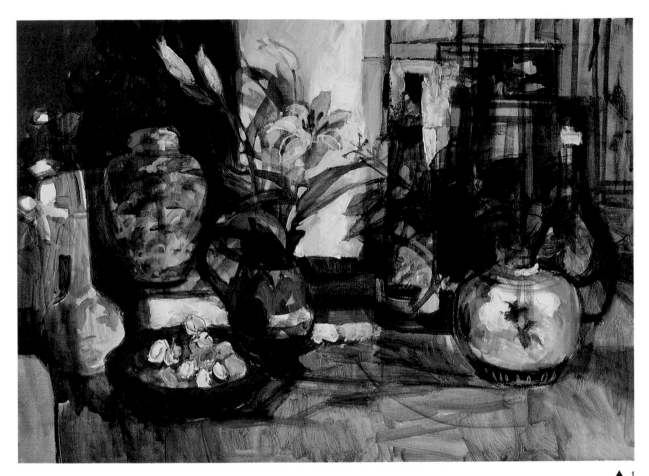

▲ 1

means that it works as a glue in effect, so you can paste down pieces of collage and glaze colours over the top, as well as hold them in place with it.

Moira also enjoys building up interesting textural surfaces by using oil pastel over the top of a composition established first in layers of acrylic paint, as in *Chinese Jar and Tiger Lilies.*

COMPOSING WITH COLOUR

Moira exploits colour differently in each work – compare the low-toned and subtle colours in *London Underground* with the brighter, vivid palette of *Chinese Jar and Tiger Lilies,* for example. Many of her works are based on and developed from specific combinations of

colours: she has found the subtle colour relationships of Ultramarine and Raw Umber especially effective for the initial underpainting in some works; while more recently she has enjoyed experimenting with brighter colours – Cadmium Red and Hooker's Green particularly. She exploits the translucent quality of thin glazes of acrylic colour to control the vibrancy of these colours by toning them down with further glazes, while allowing the brilliance of some of the underlying colours to show through in certain places. The advantage here with acrylics is that you can overlay and change colours almost immediately because they dry so quickly.

Moira looks for balances and echoes of colours throughout her surfaces. Once she has applied a colour to a particular part of the

Underpainting for Chinese Jars and Tiger Lilies
Thin washes of vibrant acrylic colour form the underpainting for this complex arrangement of objects. Here, Moira has exploited the translucency and transparency of diluted acrylic colours to develop a rich visual pattern of overlapping hues; brilliant Monestial Green over Crimson has created rich purples, while Raw Sienna over Crimson has produced vibrant oranges. The darker tones, too, have been created by overlaying successive glazes of colour. Impasto has been introduced by the application of texture paste with a palette knife, for example in the grapes in the foreground bowl (1)

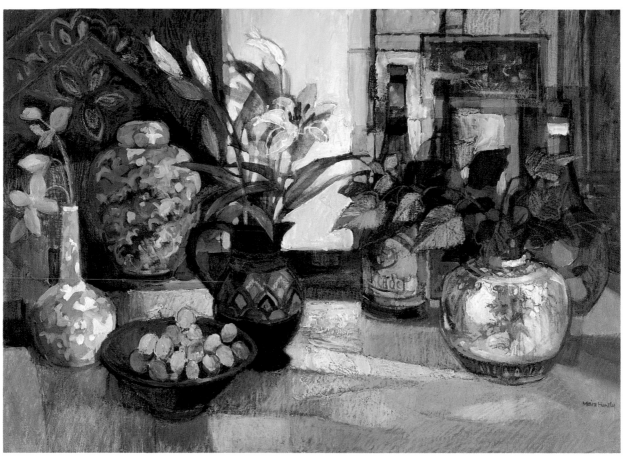

▲ 2
Chinese Jars and
Tiger Lilies
*acrylic and oil pastel on
canvas board*
510 × 710 mm (20 × 28 in)
*The brilliance of these initial
colour relationships were later
toned down, and the variety of
surface texture developed, when
Moira began to define the
forms of the objects and their
surface patterns in oil pastel,
using the medium in both a
linear way as well as in order
to develop some of the broader
compositional areas, especially
in the foreground (2)*

painting she may then consider
where else in the composition she
can put that colour, while colours
that have a predominant presence
are deliberately balanced by
accents of opposite colours. In
practice she puts down a colour,
then makes her subsequent colour
decisions in relation to what is hap-
pening on the painting surface. The
great advantage here in her method
of sometimes working only from
monochrome sketches is that she is
free to choose whatever colours
and combinations of colours she
wishes to explore: 'When working
directly from still lifes a particular
colour that features within it might
trigger your colour decisions, but
when you're interpreting pen and
ink drawings you're really free to
decide on whatever colours you
want to use and experiment with.'

A CONTEMPORARY APPROACH

Moira's work demonstrates how
artists today are free to create visual
images using a great variety of
methods and materials; and within
this Moira also reveals the definite
advantages of acrylics. With this
medium you can interpret your sub-
ject matter in less obvious ways
than in the past and she shows how
the use of a non-representational
method to explore a realistic sub-
ject can stimulate fresh ideas.

MASTERCLASS
with Donald McIntyre

One of the most striking aspects of Donald McIntyre's paintings is his obvious pleasure in the creamy texture of acrylic paint. He delights in applying the medium with a flourish of brush strokes and a heavily loaded palette knife to build up rich impastos of pure, clean colour, which contributes a sensuous, tactile quality to his paint surfaces.

Having painted in oils for many years, he now uses acrylics exclusively for his studio paintings; their quick-drying nature allows him to paint spontaneously and with freedom, and the wide range of colours available provides him with a rich palette for painting the light and colour of coastal and harbour scenes. Donald also finds acrylics much easier to work with: 'You have a limited attempt with oils, after which you have to put your painting aside to dry. With acrylics you can work on a painting much more, and more quickly, without losing that freshness, or worrying about whether the paint layers are going to crack as you do with oil paints.' Another important advantage for him lies in the fact that he can work with acrylics for much longer than he could with oils, without getting colours into a 'muddy mess'.

▶ Bunowen Harbour
acrylic on board
635 × 940 mm (25 × 37in)
The apparent naivety of this harbour scene with its simple design and tipped-up, exaggerated perspective recalls some of the primitiveness of a marine painter like Alfred Wallis. The harmony of the composition is enhanced by the repetition of the purplish and greenish blues in the sky and water, while these strong colours are lit by the vivid accents of the pale creamy colour of the left-hand building and roof, and end wall of two other buildings as well as the harbour pathway. The thick, textured layers of colour give a tactile feeling to the picture, while the nuances of warm greys and other modulated areas of colour remain clean and fresh due to the quick-drying nature of the paint

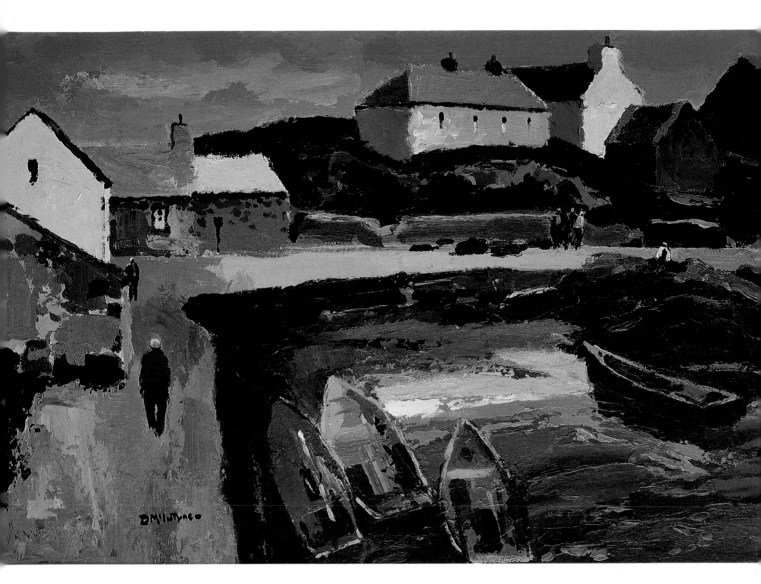

Donald working on the spot on Iona

FINDING THE SUBJECT

Donald is attracted by the quality of the light and colour in marine and seascape scenes especially, which he travels widely throughout Britain to find. The Scottish island of Iona, in particular, with its pale sands and intense blues and emerald greens of the sea, draws him back time and again. Here he might be seduced by the fleeting impression of the brilliant colours of a backwash, or the colour effects of the light hitting the sea as it breaks over a rock; sometimes he might notice the colour of the light on a rock or a wonderful streak of light on the horizon. The natural outcome of his acute observation of these effects, and constant simplification in his sketches and paintings of the essential elements in such scenes, is that his final studio paintings reflect a keen sense of the place which first inspired him. Intimate harbour scenes, too, incorporate many of his preoccupations: small fishing villages, boats, timeless places untouched by modern industrialization.

SKETCHES AND COLOUR NOTES

Transient light effects must be recorded quickly. To capture his fleeting impressions Donald makes dozens of rapid, on-the-spot pencil and watercolour sketches in which he also often makes written notes to remind himself about particular light and colour effects when he returns to the studio. There is little point for him in these initial studies in making more than cursory references to the basic shapes, colours and underlying tonal structure of the scene. His reason for this is that he knows that unless you stick to the aspect that first attracts you about a scene, you can easily become sidetracked from the important task of distilling the necessary information for the development of later paintings. Even so, he often finds that he has included more information than he actually needs. In these cases it is easy to discard extraneous elements when you start work on the painting.

An important function of responding quickly to the fleeting effects of nature in this way in rapid sketches, is the way in which this forces you to focus on the essentials and to start to simplify some of the many complexities of a view. This is especially relevant when it comes to tackling one of the most difficult elements of a seascape: the sea itself. The key to recording this constantly moving and changing element lies in careful observation, although Donald admits still to having difficulties in capturing its special qualities. His answer to those who, like him, find this aspect of marinescapes difficult is to 'just sit and watch it; try to record some of the shapes you see and aim to get the feel of the sea's movement in the marks you make'.

STUDIO ACRYLIC PAINTINGS

Back in the studio, and away from his original source of inspiration, Donald looks through his sketches to find one that triggers his visual memory to recall more about the scene than is suggested in the sketch. Interestingly, he rarely uses the best of his on-the-spot sketches because, as he says, these often make the worst paintings, 'probably because they're complete in themselves. Every now and then a sketch says everything you want to say about a subject so that when you try to elaborate on it, you fail.'

Careful analysis of the tonal structure of a scene, indicated first in his sketch and developed later in the studio painting, is essential to the success of his final composition. He enjoys manipulating strong tonal contrasts and aims to cut down the range of tones in his paintings by emphasizing and developing the most dramatic contrasts of dark and light. This heightens the impact of the painting, while an overall unity of surface is maintained by the deliberate repetition of certain colours throughout different parts of the composition. Note, for example,

The River Wharfe
acrylic on board
510 × 610 mm (20 × 24 in)
The dramatic contrast of the dark trees silhouetted against the light, wintry sky drew the artist to paint this dreamy Yorkshire scene. The abstract impression of the trees is dramatized by the pinky, creamy yellows of the background sky and this area highlights the way in which the artist seeks to 'lose and find' edges by juxtaposing and overpainting contrasts of colour as they meet each other. The stark autumnal contrast of almost monochromatic colour and thick textured paint gives the painting an almost sculptural feel

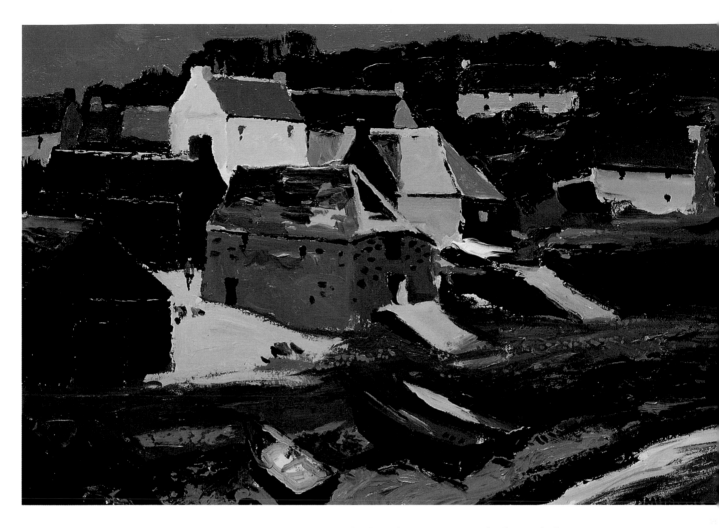

the repetition of the purplish blues in the sky, roofs, boats and beach in *Boats Cadgwith No. 3*, which contrast dramatically with the pale ochres and at the same time contribute a subtle pictorial harmony to the painting.

Donald's usual procedure in the studio is to start a painting by first blocking in the mid tones, picked out from the initial sketch, which he covers up almost entirely later on. On other occasions he might start with an exciting mark or contrast of colours, which makes him keen to paint the rest of the picture. In effect this gives him something tangible to paint from and, as he says, especially when inspiration seems to have disappeared completely, you can often 'trigger yourself off in this way'.

Boats Cadgwith No. 3
acrylic on board
510 × 760 mm (20 × 30 in)
After many months of sketching and painting on Iona and confronting the challenge presented by its complicated natural rock structures and the brilliantly coloured, moving sea water, Donald enjoys visiting small coastal harbours, where the pattern of shapes of the buildings and boats are more definite.

Exaggerating the high viewpoint the artist invites the viewer to look down on the fishing boats resting on the shore, which then lead the eye up into the contrasting jumble of buildings in the middle and background. Contrasting areas of tone define the individual buildings while the lightness of some of the walls and roofs against the dark landscape background, etched against an intense blue sky, creates a strong sense of light and is the key to the mood of the painting. Donald's exuberant handling of the acrylic medium gives the painting vitality

Cliffs near Solva
acrylic on board
510 × 760 mm (20 × 30 in)
This craggy Welsh coastline is a favourite place for Donald. It gives him scope for exploring the colours and movement of the sea as it breaks over the rocks, by the use of a great range of painted marks. These vary from the broad horizontal strokes in the background where the water is much calmer, to the stabs and jabs of smaller patches of colour in the foreground which suggest the turmoil of the waves breaking against the rocks. The horizontality of the background contributes to the calmness of this area, while the foreground is activated by the looming edge of the cliffs painted to the right

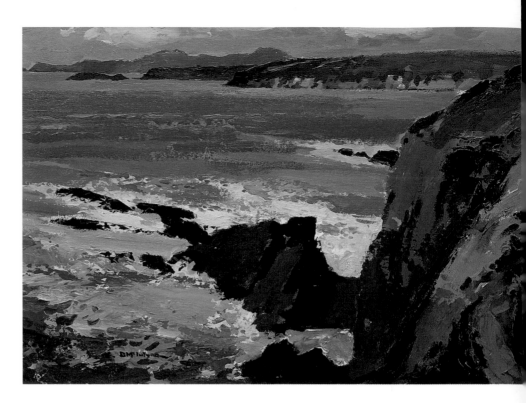

He uses buttery-consistency acrylics of varying brands and enjoys the fact that you have complete flexibility and freedom of choice about what kind of surface to paint on with the medium. He chooses either to use a thick white cartridge paper, mounted on a board, or a board covered with a white acrylic gesso ground. The advantage for him in working on these surfaces is the freedom of approach that this encourages compared with painting on the more 'inhibiting' surface of a canvas. As he says: 'You're not so worried about making a mess when you're painting on something that doesn't matter as much.' For this reason Donald reckons that acrylics are 'a very good medium for inexperienced painters'.

Once the structure of the composition is in place Donald starts to work into the painting, keeping the whole composition going, as well as the colour relationships working together and looking what he calls 'attractive', at all stages. Initially he applies his paint quickly in wet-into-wet washes, working in a traditional way from thin to fat layers, gradually building up his creamy impasto textures. At this stage the colour is heightened compared with the original study, and the entire surface becomes animated by exuberantly applied areas of thick, buttery paint.

As for most artists painting for Donald is all about accepting limitations, so keeping to the exact colour values of the original view, as indicated in his sketch, is not as important to him as the necessity to respond to the demands of the actual painting. In this respect he warns against worrying too much about achieving an absolutely faithful translation of the original subject. As he says: 'Rarely does a painting become what you first intended to paint.' In any case Donald's ultimate aim is to achieve a *sense* of place and mood rather than a literal description of his subject.

ON REFLECTION

A typical frustration when working hard on a painting is, as Donald notes, the fact that very often 'you cease to see it'. His strategy in these situations is either to turn the painting away from himself, before returning to it another day or, of more immediate usefulness, he might look at it at regular intervals in a mirror, which 'gives you a fresh view and tells you where there's a fault'. Only through experience, though, do you learn what to include, what to exclude, where any faults lie and what elements to change in a painting.

In the final stages he works into and builds up the forms of rocks or other elements by adding stronger contrasts of tone, and suggests flecks of intense light by putting in touches of bright colours such as Azo Yellow. In some paintings he ends by painting in a figure with a small sable brush to give a dramatic sense of scale to the composition, as in *Eilean Chalbha*, for example. A final application of a layer of gloss medium and varnish, followed when this is thoroughly dry by a layer of matt varnish to reduce some of the shine, brings up the darker colours and contributes to the powerful orchestration of colours typical of his paintings.

THE POWER OF COLOUR

Donald enjoys the tactile sensation of working with thick paint and putting down colour. His enjoyment of colour and its power to affect a keen sense of light, place and space in a painting is perhaps the most identifiable factor linking his work with Scottish art from the eighteenth century to the present

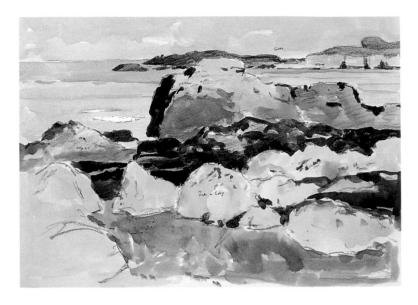

▲ *Study for* Eilean Chalbha
When working out of doors on location from his subject, Donald's first response is to sketch and simplify the main shapes in pencil, followed by colour suggestions washed in with watercolour. He might also jot down written notes; for example the yellow light effect on the top of the largest outcrop of rocks in the middle ground is noted here in pencil

▼ Eilean Chalbha
acrylic on cartridge paper 510 × 610 mm (20 × 24 in) In the studio painting Donald builds up the forms of key elements such as the foreground rocks by adding stronger contrasts of tone, and suggests flecks of intense light by putting in touches of Azo Yellow on the rocks. The addition of the figure dramatically alters the sense of space and scale in the painting

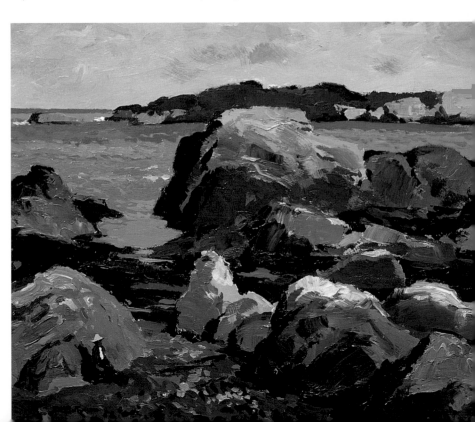

day. His basic palette consists of the earth colours, except for Raw Umber; a lot of Black, which he uses to make some of his greens by mixing it with Azo Yellow; Titanium White, Phthalo Green, Hooker's Green, Azo Yellow Orange, Quinacridone Violet, Brilliant Blue and Naphthol Crimson – the equivalent of Crimson Lake. The use of a fan-shaped brush facilitates the broad sweeps of colour that give his painting surfaces such energy, while a palette knife heavily loaded with colour enables him to 'crunch' into these layers to build up texture – an engagement with the painting in which he clearly delights. The quick-drying nature of acrylics allows him to develop these richly textured surfaces without churning up the underlying colours: 'I like to try to keep the paint clean, but I still like to get texture', which he achieves purely by using 'masses of paint' with no other medium added.

LOST AND FOUND EDGES

The issue of 'lost and found' edges is commonly discussed by artists. How you cope with the edges between colours which abut each other is especially relevant when working with a quick-drying medium since, as in the case of acrylics, you only have a short time in which to blend wet colours to lose an unwanted hard edge, which you can do more easily and for a longer period with oils. Donald frankly admits that he finds this a real problem: 'I get too many hard edges. I try and break them up, but if I try and do it too much the painting goes dead. It's like walking a tightrope.' For this reason he rarely paints in the sky at the start of a

▲ 1

▼ 2

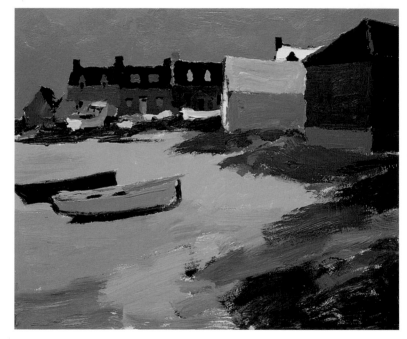

Studies for Port Ronain
This pencil and watercolour sketch was done quickly while Donald was waiting to catch the ferry from Iona (1).

For the studio acrylic painting developed from this sketch Donald used a squarer format. This decision has had a considerable impact on the design of the composition; the curving sweep of the shoreline *is enhanced and takes the viewer into the composition which now has a much greater sense of receding space. The boats have come forward and their curved shapes contrast against the buildings.*

The sky was added only after the main shapes had been blocked in, mainly because Donald enjoys etching the horizon away from the shape of the sky (2)

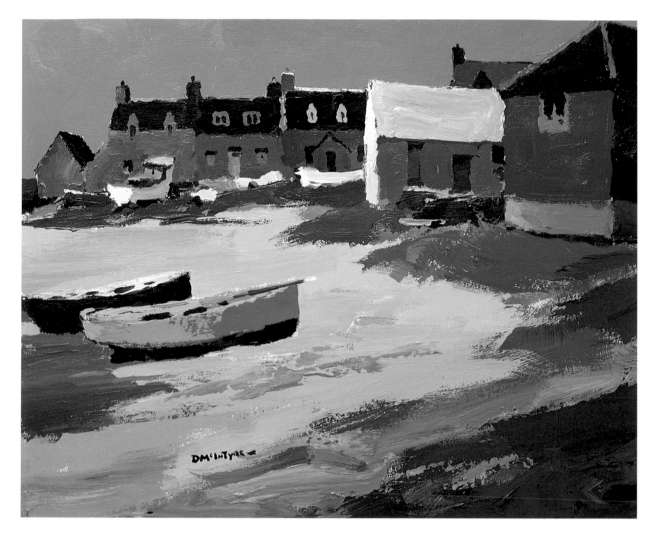

▲ Port Ronain
acrylic on board
510 × 610 mm (20 × 24in)
When the pattern of simplified shapes and the basic compositional structure is in place Donald adds smaller details, in this case the windows and doors of the buildings. He also emphasizes the sense of light in the painting by adding touches of stronger contrasts of colour to areas such as the sand and shoreline and the front of the post office building. The touch of red on the post office acts as a visual key to offset the other colours in the painting and immediately attracts the eye

painting. By leaving its inclusion until later he is able to lose some of the rigid edges where the initial blocked-in shapes meet the sky behind, as can be seen in the first illustration of the actual painting *Port Ronain*, for example.

KNOWING WHEN TO STOP

One of the hardest decisions in painting lies in knowing when to stop working. It becomes easier with experience but, even so, Donald admits to having 'ruined dozens of paintings by working on them too much. I suspect that many of the paintings you do are probably better at an earlier stage, before

they are "finished".' For him, painting is ultimately 'a bit like mining: you explore and explore; then it dries up and you keep on exploring like an idiot hoping that something else will come along.' However, the greatest satisfaction comes when, every now and then, 'you do a painting which is the start of something different in your life'.

79

MASTERCLASS
with Terry McKivragan

Of all the *Acrylics Masterclass* artists, Terry McKivragan is the most recent convert to acrylic painting. His example shows how a simple decision to change medium, as in his case from watercolour to acrylics, can have an unexpectedly large significance and take you into a new area of exploration with exciting and positive effects for your own painting.

Terry first started using acrylics after a long period of painting landscapes in watercolour. After many years of manipulating delicate watercolour washes he began to want to be able to control and build up his paint layers, without the fear of the painting becoming overworked. At the same time he felt the need to work on a larger scale, using 'a more physical approach' and to introduce a stronger sense of design, or 'pattern value' into his work. From what he had learned about the opaque, quick-drying and flexible qualities of acrylics, he decided to try them. His earliest experiments with the medium were very much affected by his experience of handling watercolour washes, and he still starts off by using acrylic paint in watercolour-like washes, before developing the subsequent paint layers with thicker, buttery-consistency paint. All his painting now is a continuous experiment in handling and evolving techniques with the medium to create the evocative atmospheric effects typical of his landscape scenes.

▶ Rye Harbour
acrylic on mounting board
735 × 735 mm (29 × 29 in)
Working usually with a fairly limited, cool palette, Terry is often relieved to find a detail in a scene which adds a 'ping' of colour to a view. In this scene he was inspired by the presence of the yellow boat, providing him with a key colour and focal point for the painting, and offsetting the more sombre purples, blues and colourful greys throughout the rest of the composition. The tiny, vague figures to the left introduce a human presence and bring a new sense of scale

◀ Terry McKivragan

81

COMPOSING FROM THE SUBJECT

Terry's main reference aid, which helps him to build up the raw material for his painting, is the camera, which he uses 'out of sheer convenience'. He can part-compose a painting via the viewfinder, and often takes two or three photographs in a panoramic sequence. In this way he can acquire a large 'library' of coloured prints of landscape scenes that attract his interest, although they do not all necessarily become translated into paintings, and are not always used straightaway; he might occasionally return to a subject over a year later. From here on, however, he aims not to follow a print too closely, preferring instead to move things around and change colours.

He looks particularly for landscapes which have a strong horizontal line. He especially enjoys the horizon line formed by an area of water meeting the land, and the sky – as in *Norfolk Broads* and *Bosham Harbour*. He is attracted by water, the sea, reflections and dramatic skies, whilst he also enjoys boats and other objects which can add interesting points of focus to his compositions. Strong light and shadows do not interest him at all; his concern is to capture and convey a sense of atmosphere – the character and drama of a place. At the same time he wants the viewer to enjoy the visual qualities of colour, shape, pattern and texture for their own sakes, just as he derives enormous pleasure from the process of manipulating these elements in his painting: 'It is, after all, a painting, so you should enjoy all the qualities of paint

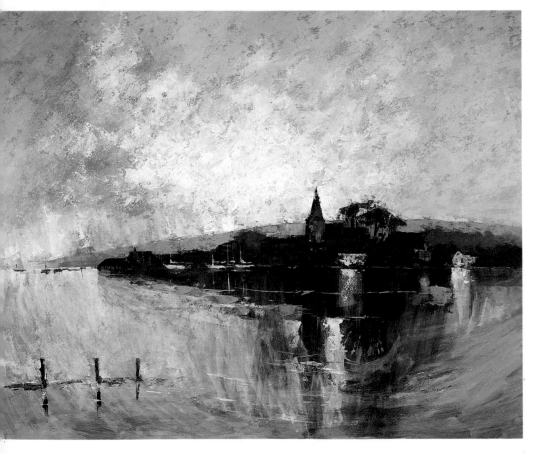

Bosham Harbour
acrylic on hardboard
890 × 1120 mm (35 × 44 in)
This fairly straightforward composition, with its simple, back-lit, silhouetted horizon line, and hardly any detail except for the vague shapes of the boats, put in with the edges of a palette knife, gave Terry an excuse to build up the textural effects which help to give this painting its misty atmosphere. The sky explodes from the underlying pinks and mauves into a blaze of white in the centre, dragged on thickly with a palette knife. This predominat area of white is reflected in the whites in the water, creating an almost monochromatic effect. This is relieved, however, by the broken effect of the paint layers underneath which moderate what could have become a monotonous pattern

itself, as long as in the end some sort of atmosphere and drama comes out of it.'

Having recorded a scene, Terry tries out compositional arrangements by scribbling in pencil on paper from his references. In these he explores the main shapes, proportions and structural lines, and decides which details might add to the composition. As it is as much about what to leave out that contributes to the success of a painting, the thought and analysis that go into Terry's initial 'scribblings' are vital.

Norfolk Broads
acrylic on mounting board
510 × 685 mm (20 × 27 in)
Terry was attracted to this scene by its simple horizontal division into a stark, dark brown foreground, offset by the intensity of the light shining on the water behind, and the vast expanse of the sky.

As a contrast to the natural forms of his landscape paintings he often likes to include an architectural element – in this case a building in the centre and windmill to the

right. The sky is, again, heavily textured; the vague sun low down adds a focal point to this vast area. To break up and enliven the almost black foreground, and to link this area with the sky, Terry introduced some of the darker purples used in the top part of the painting to the foreground, as well as some reds, magentas and greens. The suggested lines of the grasses were created by using a scalpel to scratch through these colours to the original surface

MINIATURE STUDIES

Once he has established his compositional structure, Terry prefers to explore colour, tone and texture on a small scale before working up the final painting on a larger scale. To do so he rules out an area approximately 125 x 150 mm (5 x 6 in) onto a smooth white mounting board – he never uses canvas as he prefers to work on a rigid support – and draws in the composition he feels will work best from those explored in his earlier scribblings.

Partly because these miniature studies are not the final painting, Terry finds that they are often more exciting; they seem to allow him a greater sense of freedom and more scope for enjoying the inevitable accidents that happen along the way. More importantly they enable him to pick out and exploit the shapes and exciting details that may not be so apparent at a first glance in the photograph; they also show him where he can develop textural effects, such as in the sky area in *Hastings Beach*, for example.

Starting with No. 6 sable brushes and acrylic paint thinned with water, he loosely washes in the first colours, establishing the initial, usually warm tone, from which he goes on to develop the paint layers. These are achieved by thicker-consistency colours being applied with a palette knife, which Terry uses to spread and scrape the paint to create atmospheric textural effects. The rich, dense qualities of colour and texture are obtained by applying layer upon layer of colour in this way, constantly muting and brightening the hues, allowing previous colours to blend through palette-knifed overlays. Each layer of paint is allowed to dry before the next colour is applied, which happens

very quickly with acrylics, so there is no muddying of colours.

Decisions are made at this stage that help Terry to develop the final larger-scale painting. In the small study for *Hastings Beach*, for example, you can see that he has made the sky unnaturalistically bright to offset the rest of the composition; a decision that he has repeated in the larger painting.

The mini-study too gives him clues about how he will tackle the underpainting which plays a crucial role in the final work. In *Hastings Beach*, for example, he exploited the underpainting to help create the glow of light by allowing it to break through the textured overlays of rich pink-oranges in the sky. You will also see in this painting (page 87) how he used a final wash of white over the beach to help harmonize this area with the rest of the painting. The mini-study also helped him to plan the positioning of thicker white paint to suggest highlights in the final composition.

DEVELOPING THE PAINTING

For his larger, finished paintings, Terry paints on hardboard, primed

Photographic reference for Hastings Beach
Attracted by the strong-shaped rocky cliff face and shapes of the boats, fishermen's huts and nets on Hastings beach, Terry first recorded a number of different views of the scene in several photographic colour prints such as this before deciding to make a painting based on this view

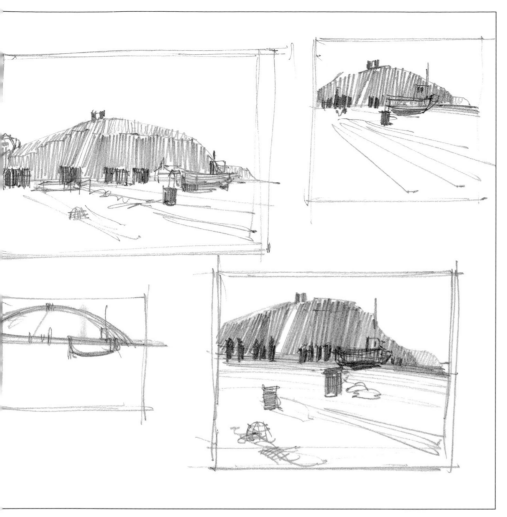

▲ 1 ▼ 2

Compositional studies for
Hastings Beach
*From his initial photographic
references Terry experiments by
scribbling down in pencil
several different compositional
ideas – varying in each one
the viewpoint and basic
proportions of foreground,
middle ground and background,
and making cursory references
to the interplay of tones, as
you can see in these scribblings
based on the photographs of
Hastings beach (1)*

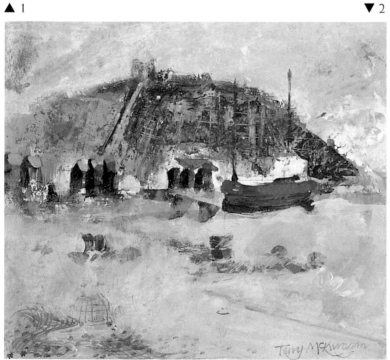

Mini-study for
Hastings Beach
*Having decided on the
compositional arrangement, he
develops a mini-version of the
final painting on mounting
board (approximately
127 × 152 mm, 5 × 6 in). This
helps him to decide on the basic
shapes, colour and areas in
which he might develop
interesting textures in the final
painting. For these mini-studies
he uses small square-edged and
sable brushes, and a small
palette knife for applying the
thicker applications of paint in
the areas, such as the sky, in
which he wants to build up
texture (2)*

with a coat of white acrylic gesso and a further coat of gesso, often tinted with a colour sympathetic to the colour theme of the painting planned. For smaller paintings he uses a range of mounting boards. On these surfaces he first splashes on a wash of watered-down acrylic colour – again usually a warm tint – using a large, soft mop brush. This allows him to 'slop the paint around a bit' and determines the uneven effect which he likes to achieve.

He next adds a pencil outline based as far as possible on the composition decided upon in the miniature study. The problem here though, as Terry frankly admits, is that a small-scale work does not necessarily translate successfully to a larger scale, and the change of proportion from a small square to a larger horizontal format also means that he must be prepared to make changes. With acrylics, the artist has the freedom to do this: 'With acrylics, if something isn't right I know I can work on it and change it quite drastically. Here the quick-drying qualities are very important. The idea of waiting for oils to dry horrifies me!'

During the early stages of the painting Terry again uses soft mop hair brushes to slop on wet washes of thinned acrylic colour, purposely avoiding keeping to his pencil outline. He loosely blocks in the main areas of colour in this way, deliberately allowing the ground to show through in many areas. Gradually he introduces more colours with a wider flat bristle brush to add variety and vitality to his range of paint marks, occasionally drying wet applications with a hairdryer to stop the colours bleeding together. This speeds up the process and the spontaneity which this engenders adds to the 'fun' of acrylics for him.

▲ 3

▼ 4

Hastings Beach

510 × 685 mm (20 × 27 in)
For the final painting, he first uses a soft mop brush to slop on a deliberately uneven wash of colour sympathetic to the colour theme of the painting planned before sketching in with pencil the basic outlines of the composition, keeping as far as possible to that indicated by the mini-study (3).

Using the paint diluted heavily with water, he brushes colour onto the composition rapidly and boldly (4). This sets up qualities of colour and rhythmic brush marks that he can play against later, and provides the suggestion of the darker tones that will underpin the vivid qualities of the overlaid textural paint in the next stages.

Next, he starts to apply thicker paint with a palette knife, hinting at the texture of the various elements in the scene and adding 'pings' of bright colour (5).

The colour and texture builds up into a more complex painting as Terry works into the main areas and the details, defining and redefining, and sometimes softening edges that may have become too obvious.

The thin lines of the boat masts were added by applying paint to the edge of the palette knife and pressing this onto the painting (6)

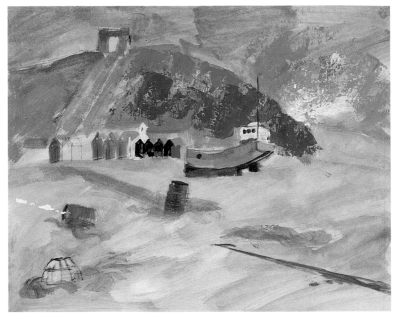

▲ 5

▲ 6

Battersea Park
acrylic on mounting board
510 × 685 mm (20 × 27 in)
Terry lives in a flat overlooking
Battersea Park, so as a subject
it is highly familiar to him.
What fascinated Terry about
this particular view was the
contrast of the dark foreground
shadow of the tree with the
pink blossom of the trees on
the horizon, and the industrial
skyline of London.

To emphasize the pinks of the
blossom he darkened the blues
in the sky, while the yellow-
greens just beyond the shadow
of the foreground tree give a
strong sense of the light
illuminating this scene. Many
layers of thin glazes of
different greens, overlaid by
more layers of thicker paint,
palette-knifed over the
foreground, contribute to the
textural area of grass and
dark shadow

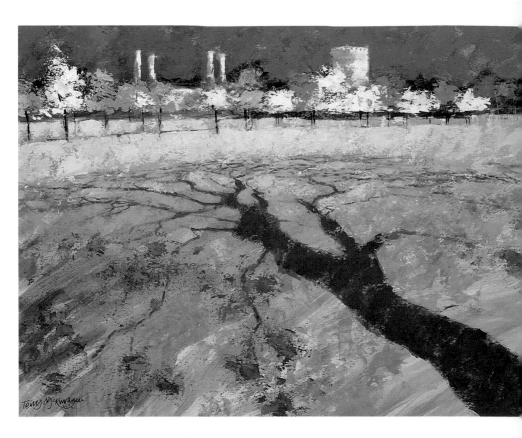

IMPASTO LAYERS

Occasionally Terry might leave an area of a painting in this often turbulent state of gestural, translucent washes, as in the sky in *Devon Coast*, for example. Otherwise he will then begin the longest process in the painting's development by building up layer upon layer of tube-consistency colour, applied now with a palette knife, as in the later stages of his miniature studies.

The most critical and largest areas, such as skies, which tend to set the tone for the whole painting, are 'pinned down' first using his palette-knife impasto technique. In building up his surface colours in this way Terry continually refers back to his references for guidance, aware all the time that he must avoid trying to include too much detail – a danger for all painters: 'The advantage with acrylics is that you can overpaint with thick palette-knife applications and break up lines or details which have become too distinctive.'

The especially rich, dense qualities of colour and texture are now obtained by this continual process of laying on different nuances of colour with his palette knife, until he sees the right effect. For practical and economic reasons he adds gel medium to his colours to add body and extend them further without having to use too much tube colour. Then, for the final touches he might use a variety of techniques to suggest some of the finer details. In *Hastings Beach*, for example, he has scratched wet paint with the end of his brush to imply the texture of the nets. But the subject remains paramount: 'It's all about producing effects which are exciting to look at, but which do not become the effects of technique for its own sake – they must say something about the atmosphere of the subject.'

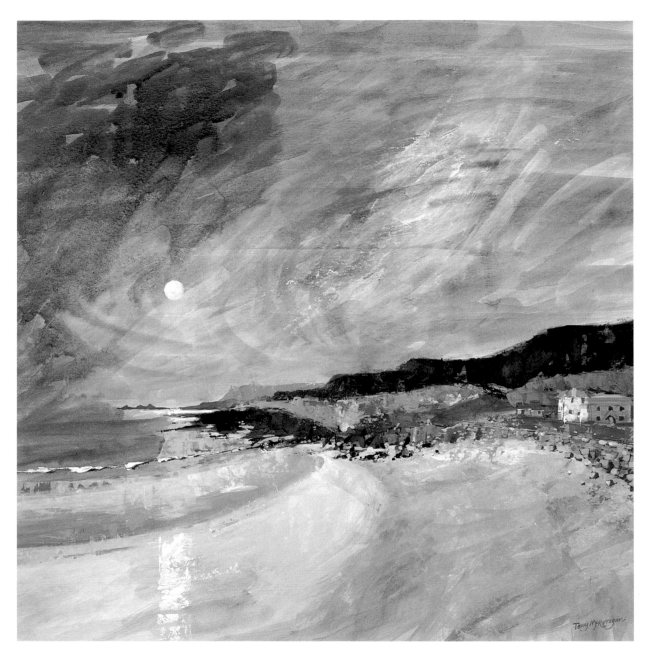

Devon Coast

acrylic on mounting board
735 × 735 mm (29 × 29 in)
The swirling turbulence of the sky, complemented by the broad-sweeping curve of the beach, draws the eye into the centre and horizon line of this stormy coastal scene, based in its compositional structure on some holiday photographs. The colour has been developed independently of these references, however, especially in the sky, which depends for its rhythmic movement on freely applied glazes of thin washes of colourful greys, lightened on the right-hand side by a more opaque palette-knifed area of white. These fairly thin washes, applied with a soft mop brush in sweeping brush strokes, predominate; by contrast, some areas of the land on the horizon, and the reflections of the sun on the beach, have been built up with textured applications of thicker paint – adding to the drama of the scene. The opaque white sun provides a calm focal point in the painting. The veils of white, lightly applied in thin washes at the end, contribute to the atmosphere of the scene

WORKING WITH COLOUR

Terry's materials include large housepainter's brushes and soft mop brushes for the early stages; followed by watercolour, then bristle brushes of various sizes and a palette knife for the final stages. Terry buys his colours in tubes, which he squeezes out and mixes with a brush. For thin glazes he mixes colour with water in china bowls. For thicker paint applications he mixes the colours, often adding gel medium to thicken and extend the colour, on a piece of non-reflective glass underneath which he places a sheet of white paper to show up the hues more clearly.

As Terry mixes only a small amount of colour at a time, he does not always achieve the same colour the second time around. This is deliberate on his part, however, as it ensures a lively build-up of colour in his work

Terry candidly admits to having to 'work hard' with colour. He also confesses to having 'a bit of a battle between using colours that are true to life and those which are best for the painting'. He prefers a basic palette of Cadmium Red, French Ultramarine, Burnt Umber, Cadmium Yellow, Permanent Green, Yellow Ochre and White, with occasional small amounts of Magenta and Turquoise which he mixes with other colours to give them an added visual 'ping'. Compared with watercolours, acrylic colours tend to be bright, but Terry finds this an advantage: by starting with a fairly bright hue, he is forced to modify and control his painting by the manipulation of subtle colour relationships.

For convenience Terry squeezes out his colours onto a piece of non-reflective glass with a white sheet of paper underneath to make them clearer to see. When he works with diluted washes he mixes his colours in small china bowls; later, for his impasto layers, he mixes small amounts of colour on his palette with his brush. The advantage of mixing up only a small amount of colour at a time means that when he tries to repeat the mixture he rarely achieves the same colour again; this results in the huge variety of subtle optical colour mixtures which are crucial to the sense of liveliness of his paintings.

Terry's usual practice is to work from a warm, bright, although tonally fairly dark, base colour through to cooler and lighter colours. As with many artists greens present him with particular problems; he usually mixes Yellow Ochre or Cadmium Red with Permanent Green either to mute it or to make it warmer. In this way he overcomes the brightness of green which can often unbalance a painting. The most useful colours for him are French Ultramarine and Burnt Umber, which he mixes to create different degrees of muted blues through to lively greys with the addition of white. In the final stages of a painting he frequently finishes by applying slashes of pure white paint – a practice which can introduce a dramatic sense of light into the composition.

Terry's highly effective method of producing atmospheric blends and veils of colour by overlaying thin washes and then impasto mixtures of colour, and by allowing colours to break through from previous textured layers, occasionally results in an unharmonious final surface. To restore unity he glazes a thin wash of colour over the whole surface, which effectively 'fills in all the holes' and 'binds' the surface together again. He also repeats similar colours throughout the entire composition which, again, helps to create a sense of harmony.

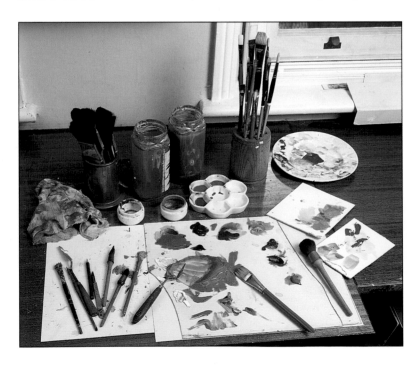

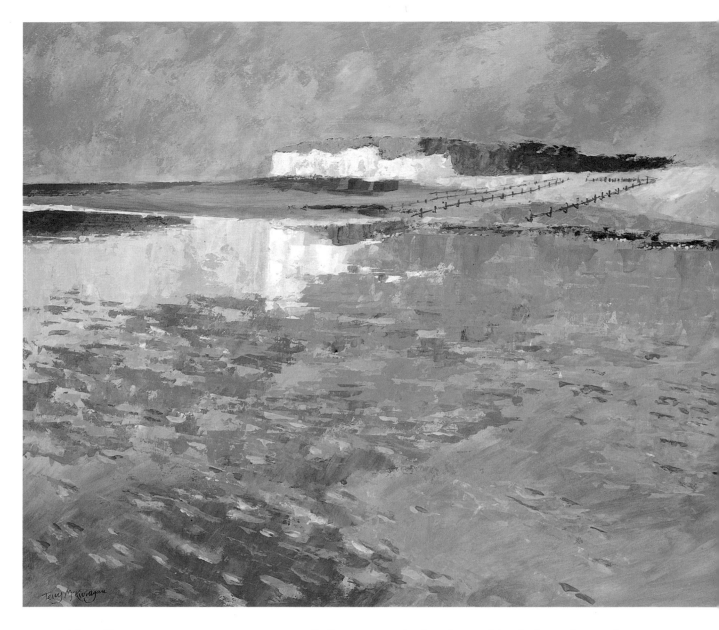

NEW POSSIBILITIES

Terry is fascinated by the paradox between the importance of the subject and the way in which 'enhancing this and putting it over in a dramatic way, using the qualities of paint, takes over'. As he says: 'Acrylics have opened up a new sphere for me. I like their flexibility to do watercolour and impasto techniques. You can do so much with them. They're easier to cope with than watercolours because you can alter things so easily.'

Reflections on the Beach
acrylic on mounting board
510 × 685 mm (20 × 27 in)
Here, the high horizon line has allowed Terry to explore the vast expanse of sand, and reflections on the beach, by building up many textured layers of opaque paint, dragged across the surface in places with a palette knife. The muted ochre colour of the sand is a mixture of Yellow Ochre, Burnt Umber and Ultramarine; the salmon-pink dabs of colour indicating the sun reflecting off the dry ridges of sand act as a key to these subdued colours.

Typically, there are no hard edges in this painting: the broken line at which the sky and land meet has evolved from the many different applications of colour to both these areas – Terry never attempts to tidy up such lines, preferring them to form naturally during the development of a painting

MASTERCLASS
with Leonard Rosoman

Portraiture has numerous facets and can convey many different messages; amongst many other functions it can act as straightforward description or as the vehicle for the artist's enjoyment of the formal aspects of painting. It is a subject rich in complexities which many people find difficult, not least because of the pressure they feel to achieve an accurate likeness of the person. Leonard Rosoman, on the other hand, takes a different approach. For him the achievement of a realistic description is not as important as the expression of his sitter's persona, or of the tensions and sympathies between the people in a group situation, which he achieves through his manipulation of the structure and space of the composition, his use of glazes and opaque areas of acrylic colour, and the environment surrounding the figures. Although most of his portraits capture the appearance of his subjects accurately this is, surprisingly perhaps, not the overriding consideration when he starts a work. He believes strongly that 'a portrait must be a painting first and a portrait second'.

▶ Portrait of Lord Esher
acrylic on canvas
1120 × 1470 mm (44 × 58 in)
REPRODUCED COURTESY OF THE RCA
Commissioned by the Royal College of Art, it was decided that this should not be a straightforward boardroom portrait. During 'sittings' at his studio, Leonard discovered that as an escape from some of the pressures of RCA work, Lord Esher used to walk up and down the avenue of plane trees in Kensington Gardens, which prompted Leonard to include the imaginary painting of this view behind Lord Esher's seated figure.

The exaggerated perspective of the windows on the left allowed Leonard to include more of the view outside, linking with the blue sky in the painting of Kensington Gardens on the easel, emphasizing the ambiguity of this painting within a painting

▶ *Leonard stands at his easel to paint and uses a mahl stick to lean against a dry area when drawing or painting on another area of the canvas*

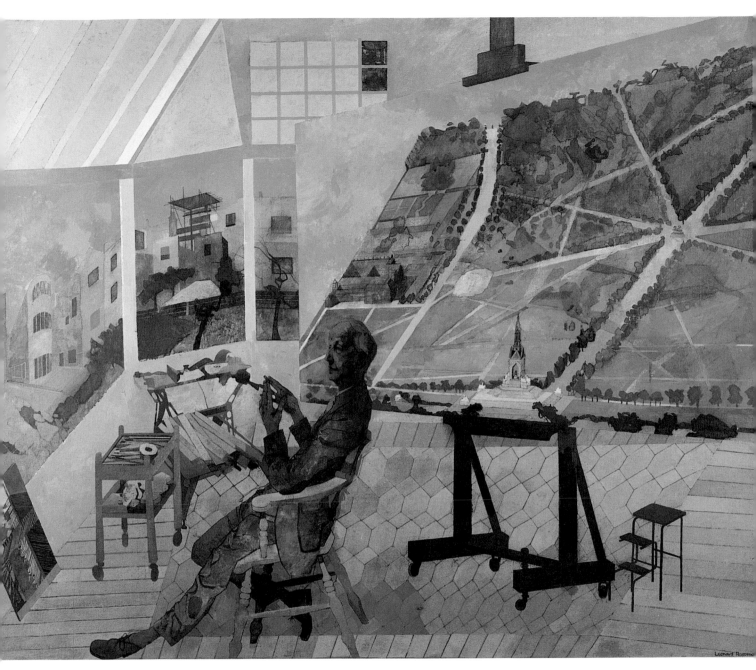

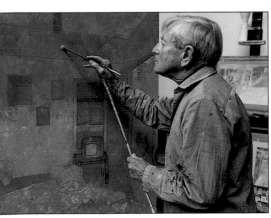

▶ *This intricate pencil study of Lord Esher's profile was done as the RCA portrait developed. It helped to answer certain questions about Lord Esher's facial characteristics that had arisen for Leonard at a particular point in the painting of the portrait*

AN ACCUMULATION OF IDEAS

Initially Leonard collects ideas and information for a portrait by talking to, and carefully observing the person, or people, to be painted. At this stage the most important activity is the looking and thinking – he makes very few notes or drawings, especially during the first meeting. His aim is to observe the shape a person forms when they relax, to see how they react to an idea and to become familiar with their posture, gestures and particular expressions. As he says, 'I have to know what they think about before I study what they look like.'

Leonard likes to restrict the amount of visual information he gathers by limiting his time with the subject to only a few sittings. At the last sitting he might ask the person to walk around while he makes notes and drawings in his sketchbook. Photographs are often useful for recording information as reminders, but details from them are never copied or used literally. As for all his work there is a large emphasis on gathering information which is 'going to be developed in some way and put somewhere'. Inevitably, of course, he ends up with too much material and much of it has to be rejected. The important decision is in selecting which material to use since, as Leonard explains, 'a work doesn't advance by adding more detail'.

There is an intimate dialogue between the artist and sitter in portraiture which often influences how a work develops. Leonard's conversations with his subjects may suggest the most ideal environment in which to place them, or perhaps the most revealing objects with which to surround them; his discussions may also introduce an unexpected or new element to the work – something which the artist believes you should always remain receptive to. For him 'the whole business is a matter of discovery, just as the finished result should be a matter of discovery for the spectator. The actual discovery while you're painting is a really marvellous thing for a painter to experience.'

The understanding and knowledge built up between artist and subject during these early 'sittings' is the key to Leonard's most successful portraits, which are generally those of people and situations he has 'learnt something about'. There is a danger, on the other hand, of attempting to treat the subject 'too specifically', of striving too hard for a likeness, which is often the reason for his least successful works. As he says: 'It's a great mistake to think that a likeness, the length of a nose, the width of the eyes, is absolutely paramount. Of course these elements are important, but they're not the most important; the most important thing is to treat the whole structure of the painting as a painting.' Like most artists he finds a constant struggle between dealing with the character of his subject and the painting as an object in itself.

COMPOSITIONAL STUDIES

Once the preliminary stage is complete Leonard assembles all the information in his studio where he 'considers it, takes it apart and reassembles it' privately. This helps to put a distance between himself and the sitter, enabling him to concentrate more on the actual painting and the ideas he wishes to develop rather than on details such as 'getting a mouth exactly right'. On some occasions he might then

Photographic studies for the RWA portrait
Photographic colour prints provide Leonard with useful basic references for his paintings. For the portrait of the council members and three past presidents of the Royal West of England Academy he took up to 50 photographs of the RWA gallery environment (1), and the artists in various situations discussing the selection and hanging of the annual exhibition. Some of these were much more important than others for the final painting: the group photograph of Warren Storey, Jean Rees and Peter Thursby (2) was particularly useful, although Warren Storey's gesture has been adapted from another photograph (3). Note, too, how the scale of these figures and their angle as a group have been altered to add to the overall rhythmic structure of the final composition (page 98). Comparison of the photograph of the interior (1) with the final painting, and one of the photographs of the view through the window beyond the door of the gallery (4), shows how Leonard widened the opening from the gallery to the window in order to open up the space in the composition of the painting.

One of the photographs of Peter Folkes (5), taken in the studio once the painting was in progress, provided Leonard with the idea for Peter's pose in the middle group behind Bernard Dunstan

▲ 1

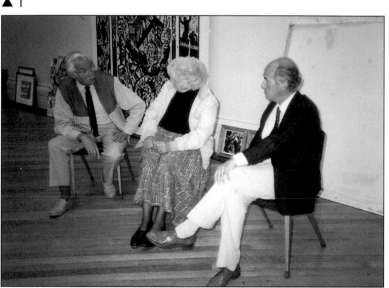

▲ 2 ▼ 3

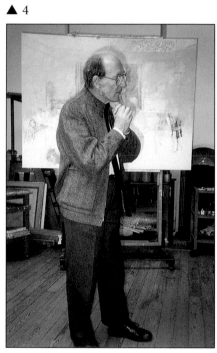

▲ 4

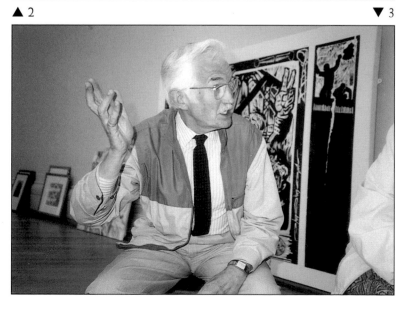

▲ 5

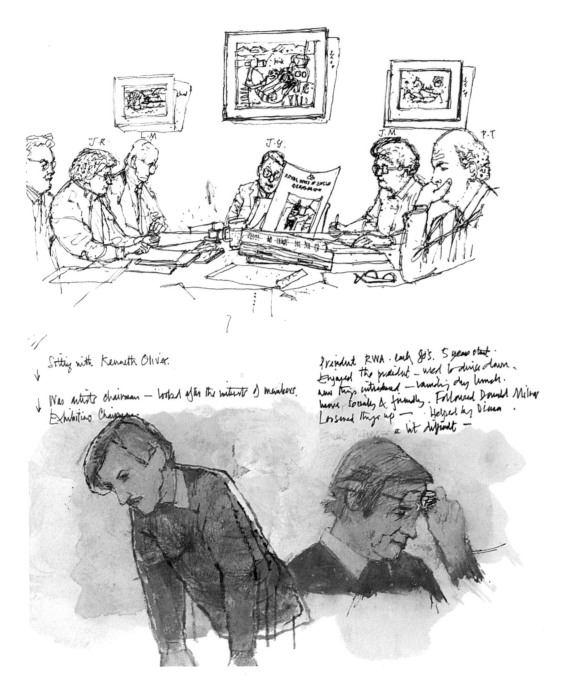

go straight into a painting, although more often, to help decide on the composition for the final work, he makes small-scale sketches in pencil, chalk, charcoal and watercolour. These 'linear indications' act like 'launching pads' to larger works. Through these he might explore many different versions of an idea and when seen together they document many changes of mind. Some reveal a fairly elaborate drawing of a small part of the final painting. Sometimes, when the final painting is complete, he might go back to one or two of the studies leading up to it and develop these into other paintings.

At this point he often has a rough idea for the final work, although he

Preparatory sketches for the RWA portrait
For the RWA portrait Leonard also made around a dozen sketches at various RWA council meetings, using pen and ink and watercolour wash, noting architectural details, gestures, posture, facial expressions and hair colour.

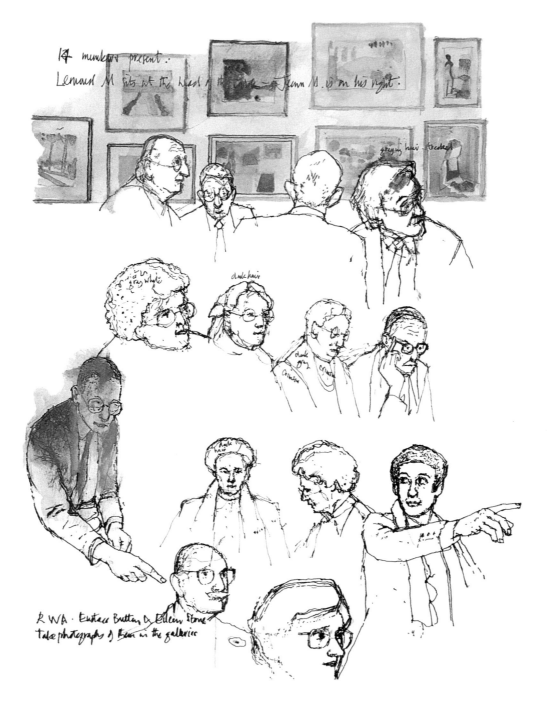

His aim at this stage in writing notes about the individual members of the RWA was to familiarize himself not only with the appearance of people and elements to be included in the painting, but also to establish an understanding about the relationships between the artists rarely fixes the component parts of a painting until fairly late in its development. This is because he likes to be able to move and change the position or scale of the figures or elements in a scene as it develops in order to affect its visual and psychological impact on the viewer. As the painting of the members of the Royal West of England Academy progressed, for example, he decided to increase the size of the doorway from the gallery to the window to enable him to include more of a view into the street and buildings beyond, opening up the space and introducing a sense for the viewer of being inside the building and looking out through the room to the world outside.

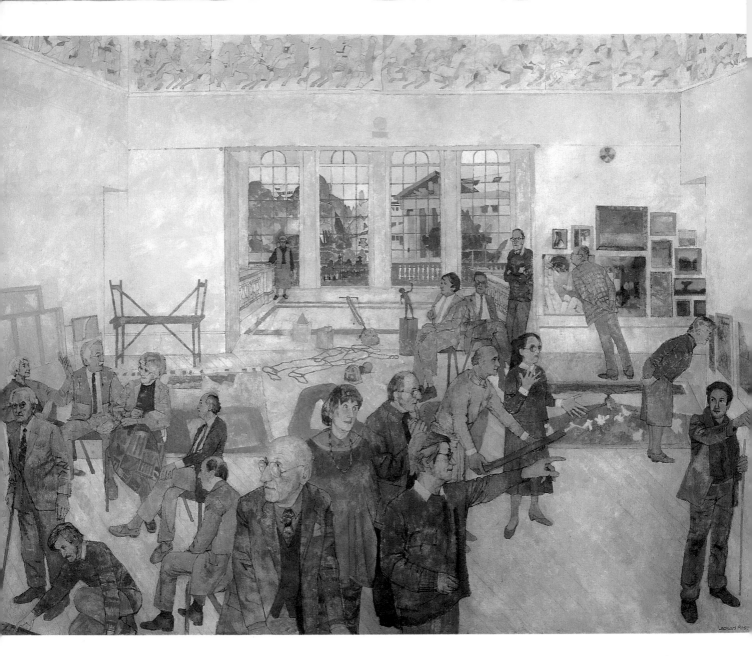

Portrait of the 1989
Council of the Royal
West of England
Academy and three Past
Presidents
acrylic on canvas
1390 × 1830 mm (54¼ × 72 in)
REPRODUCED COURTESY OF THE RWA
*By exaggerating the tipped-up
perspective of the floor and
box-like shape of the gallery
interior, Leonard started by
setting the scene for this
complex group portrait, in a
manner similar to a theatre
director preparing the stage
set for a play. Once the
environment was established in
this way, he began to add the
figures gradually, using
opaque paint in places to paint
out and move their positions
when required as the painting
developed. The figure of
Donald Milner at the extreme
left of the painting was first
positioned nearer to the centre
of the picture, for example; and
the prominent group in the
middle foreground of Leonard
Manasseh, Mary Fedden
and Peter Folkes, with whom
Leonard started, were not
absolutely fixed – their
positions moved up and down
and from side to side as the
painting progressed.*

*The organization of the
space in the painting creates a
balanced composition in which
the eye is led from the middle
foreground figures into the*

background right activity, and middle foreground left-hand group. The two paintings lying on the floor towards the back of the gallery are important keypoints which arrest the eye, while the kneeling figure concentrating on something outside the picture, bottom left, and the pointing figure on the extreme right, take the viewer out of the confines of the canvas – a typical feature seen in many of Leonard's paintings.

Contrasts in scale add to the liveliness of the painting. Leonard has made a particular play on this aspect, especially in the contrast in scale between the large head in the painting on the wall at the back of the gallery, and the impossibly leaning figure of Eustace Button looking at it.

The result is a fascinating and engaging compilation of the activities that take place during the selection and hanging of an RWA exhibition. Although the individual portraits of the RWA members are of course important, the overriding interest for the viewer is in unravelling the narrative behind the painting

▲ *The 1989 Council and three Past Presidents of the Royal West of England Academy*
1 *Jean McKinney (secretary)*
2 *Le Clerc Fowle.* ROI, RWA
3 *Donald Milner,* PPRWA
4 *Kenneth Oliver,* RWA
5 *Warren Storey,* RWA
6 *Jean Rees,* RWA
7 *Peter Thursby,* FRBS, RWA
8 *Arnold Wilson,* MA
9 *Leonard Manasseh,* OBE, RA, FRIBA, PRWA
10 *Mary Fedden,* PPRWA
11 *Peter Folkes,* RWA
12 *Bernard Dunstan,* RA, PPRWA
13 *Denys Delhanty,* RWA
14 *Margaret Lovell,* FRBS, RWA
15 *John Keeling Maggs,* RIBA, ARWA
16 *John Gunn*
17 *Tom Burrough,* RWA
18 *Eustace Button,* FRIBA, RWA
19 *Aileen Stone, Hon* RWA
20 *David Carpanini,* RWA

TRANSFERRING SKETCHES

Early compositional studies can be very useful in working out a larger design for a finished painting, but Leonard cautions against the idea that they will answer all the problems of a larger-scale work. As he says, 'if you transfer a sketched idea onto a painting or a mural, you've got to find equivalents for what went before. You can't just repeat the sketch; if you do that, the larger work will fail.' For the 37 m (120 ft) long vaulted ceiling at Lambeth Palace, as one particular example, he prepared a large preliminary compositional drawing which, when transferred to the ceiling, became so distorted by its curves that he had to make an enormous amount of adjustment to it to make the design work.

A PREFERENCE FOR ACRYLICS

Leonard Rosoman's work has become synonymous with acrylic painting. He has used the medium exclusively in preference to oils since the 1960s when he first became excited by their many unique qualities. For him, the use of acrylic paints encourages a looseness and freshness of approach and allows the painter to progress quickly through layers of paint without resulting in that rather tired, 'heavy' look that oil paintings can develop from time to time: 'Even if you build up a heavy impasto, which I do very occasionally, it doesn't go dead on you and the surface of the paper or ground is allowed to live and play an important part in the work.'

Layered, transparent glazes of thinly applied colour which resonate from the picture surface are inherent qualities of Leonard Rosoman's paintings. The delicate, glowing effects typical of his work are characteristic of the medium when the paint is diluted with water and transparent colours are glazed one on top of another. Because of their quick-drying nature you can overpaint layers of thinned acrylic colours with great speed, and contrast these areas by introducing opaque layers with more 'body' to build up a variety of surface effects. Another important advantage of using the paint in an opaque consistency is the opportunity this offers to overpaint and eliminate unwanted areas very easily — an advantage which Leonard often exploits to alter the positions of the figures or various elements in his compositions as they develop. For example, the figure of Lady Irvine was originally nearer to the centre of the composition before he decided to move her to her present left-hand position in the painting.

Acrylics are also preferred by Leonard because when used thinly the colours dry with the kind of matt, even surface consistency that he enjoys. As an established mural painter, too, the medium is ideal for him as it adheres well to any grease-free surface. Moreover, because they dry quickly the colours are not prone to alteration by dust particle absorption in difficult environments such as in the case of the Lambeth Palace commission when a lot of dusty building work was going on at floor level while the artist was painting the ceiling. Also, perhaps the most fundamental advantage of the medium for Leonard in relation both to his paintings and murals is the fact that, 'as tested so far, it is about as permanent a medium as you can get'.

SELECTING COLOURS

Leonard notes that it is difficult to say what makes a 'good colourist' since 'colour is what you make of it'. Habit plays an important part in selecting colours; indeed most artists' palettes consist of a personal selection based on taste and experience. Many of Leonard's paintings tend towards a warm orange yellow glow — not the easiest colour to handle — and he is known for his predominant use of oranges and blues, as in his *Portrait of Lord Esher*. He limits his palette to about ten or eleven colours including Titanium White, Lemon Yellow, Yellow Ochre, Cadmium Orange, Cobalt, Ultramarine, a little Cerulean, Vermilion, Cadmium Red, and a deep as well as a lighter Violet. He prefers not to use much Black; instead he achieves his darks

Cat Attacking Grass
acrylic on canvas
1015 × 1270 mm (40 × 50 in)
To some extent this painting is also a portrait — of Leonard's cat, a member of the Korat

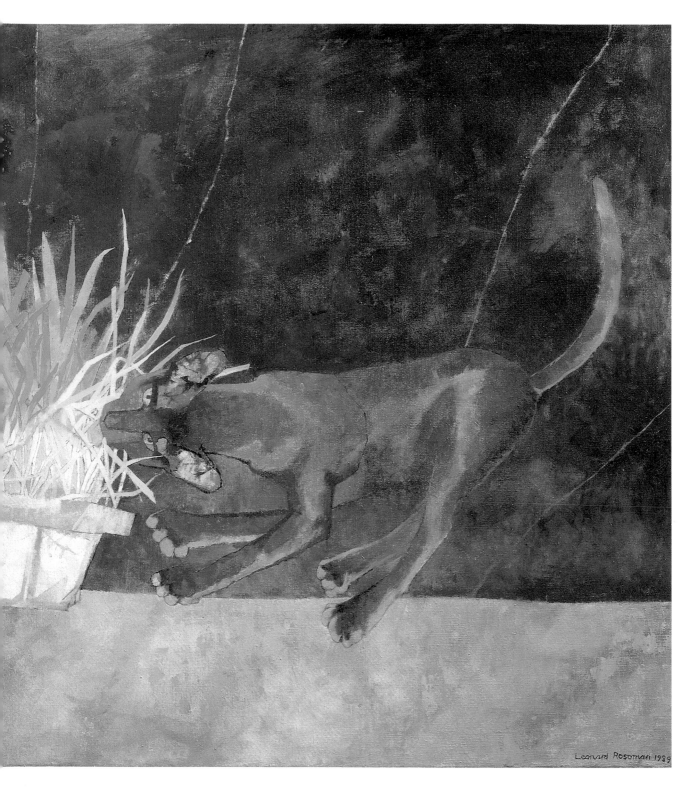

Leonard Rosoman 1989

breed originating from
Thailand. Bewitched by his
athletic games, Leonard has
made many studies of him.
This painting captures his
memory of the moment when
the cat went for this curious
and rather exotic tub of grass.
Our concentration is focused
completely on this one
extraordinary gesture of the
cat attacking the grass. The
ambiguous background acts as
a backdrop to the drama, which
is heightened by the suggestion
of streaks of lightning in the
diagonal lines etched through
this dark area

▶ Portrait of Lord and
Lady Irvine
each canvas 1170 × 1170 mm
(46 × 46 in)
acrylic on canvas
REPRODUCED COURTESY OF LORD
AND LADY IRVINE

*This double portrait of
husband and wife was conceived
as a diptych and is framed as
one work with a small gap in
between the two canvases*

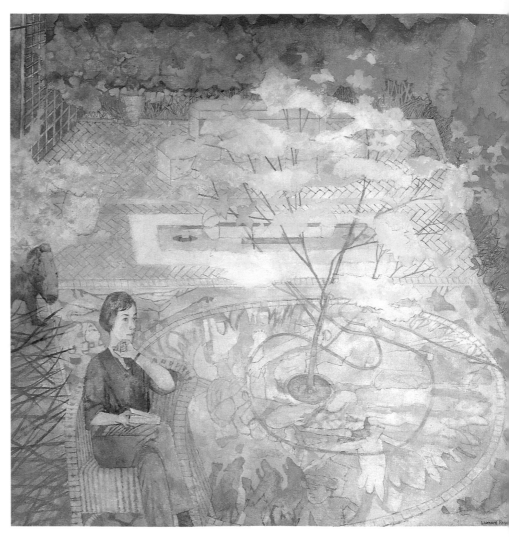

*In the early 'sittings' Leonard
discovered the importance for
both Lord and Lady Irvine of
their garden, with its
decorative mosaic and sculpture,
of which he made a delicate ink
drawing (RIGHT). After taking
many photographs and
making a number of rapid,
on-the-spot studies of Lady
Irvine sitting reading (ABOVE),
he decided to portray her thus
in this outside environment. He
also photographed and made
studies of Lord Irvine sitting
underneath the Claude Rogers
painting* The Hornby
Train, *which hangs in his
house (page 103). He decided*
*to develop the theme of Lord
Irvine with the painting, and
to contrast this with the
painting of Lady Irvine outside
in the garden*

102

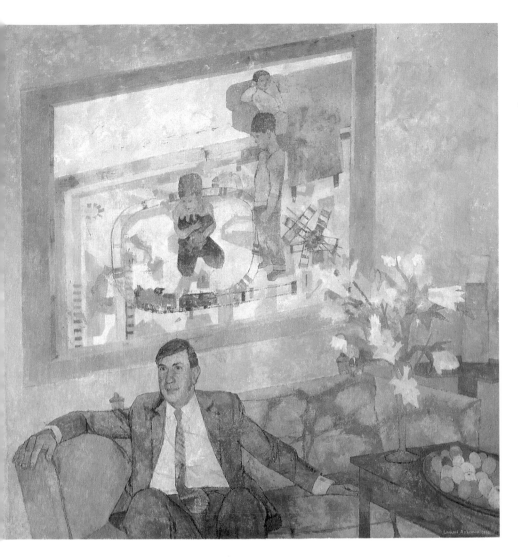

After starting the painting of Lord Irvine, Leonard began the painting of Lady Irvine quite late in the development of this first canvas, after which both progressed side by side. The problem with a diptych, as Leonard experienced, is that you must achieve the maximum energy in one painting as an isolated object, as well as link the two, without overbalancing one by the other. For a time Leonard worked on the two paintings in opposing positions – with the painting of Lady Irvine on the right. At this stage he began to develop the links between the vase of flowers to the right of Lord Irvine by exaggerating its importance, and the foliage in the garden environment. In the end, however, he returned the paintings to this arrangement.

Both figures are placed low down in each of the compositions, which allowed Leonard plenty of room to show the importance of the environments in which they are situated. Lady Irvine's position began nearer to the centre of the painting, but by overpainting with opaque paint, Leonard moved her more to the left to allow him to show more of the pattern of the garden mosaic.

Echoes of the orange-red in the Rogers painting connect with the thin line of sky and mosaic in the portrait of Lady Irvine, while the greens in the still life are repeated in the foliage of the garden. The paintings resonate with a pink-orange glow resulting from the many glazes of acrylic colour flooded and worked into the canvas surfaces

by mixing together other colours with a deep colour value – deep purple and deep green give you an 'almost black', for example.

His decisions about which colours to use for a painting derive from particular cues in his subject, which he uses to initiate the development of colour throughout the rest of a painting. In the portrait of Lord Irvine, for example, he took his cue from the red sofa in the Claude Rogers painting *The Hornby Train*, seen hanging on the wall behind the peer, using this as the focal colour for the new work, changing its actual hue by muting and toning it down to suit the mood of the portrait.

THE DEVELOPMENT OF A PAINTING

Leonard describes himself as a fairly slow worker for whom one decision leads to another as he develops a composition 'bit by bit'. For his finished paintings he works mostly on medium-textured canvases primed with two coats of acrylic gesso primer. The strong linear element to his work originates from the delicately drawn structure underpinning each of his compositions. Once the figure and other elements have been stated in this way he begins to draw with colour, not necessarily adhering to these initial drawn boundaries. He starts to introduce colour by selecting an area, or a shape – surprisingly not always the focal part of the design – and washing a diluted colour over it, easing this thin glaze out into surrounding shapes with his brush, before gradually adding and spreading other thinly diluted colours until the entire canvas is covered with colour. He emphasizes that the important point to consider when using this technique is how much the drying time of the medium affects the degree of positiveness of a shape: 'The sooner you flood a colour with a broad brush the less that colour will rest in a particular shape; if you leave the wet colour for a bit it will establish itself so that when you come to flood it into a larger area this will take away a bit of it, but not as much as if you flood it immediately. The longer you leave a wash, the more positive the shape will remain.'

By pushing his brush against the canvas and working the wet paint into its fabric, rubbing the colour into it – sometimes with a rag – rather than allowing it to flow, Leonard is able to control his glazes and avoid problems such as colours dripping down the canvas.

The basic shapes and structure of the composition are the first essentials. For very large areas he sometimes uses 50 or 75 mm (2 or 3 in) housepainter's brushes, although most of the time he paints with smaller sable brushes. His method of working, which he describes as 'dealing with a shape and allowing it to suffuse with its surroundings rather than slotting together areas like a jigsaw puzzle', lends a wonderful sense of cohesion to his finished paintings.

The details are then added, or restated, fairly late in the painting's development. Facial characteristics are drawn in with paint, using a very small sable brush and a colour that works with those that are already on the canvas. At this stage, Leonard is also redefining some of the initial, underlying linear structures. In effect, he might now be dealing with two versions of a particular detail, such as a head or a hand – according to how much he has altered their positions from the original drawing. These are then sometimes combined into one final result; a method of drawing with the paint which, as Leonard notes, helps to keep the painting alive.

DISTORTING THE PERSPECTIVE

The unusual spatial arrangements typical of Leonard Rosoman's paintings enable him to manipulate the psychological tensions in a scene, or reveal more about the personality of the sitter. Leonard distorts perspective freely, bending it 'this way and that so that the picture becomes something new; something that's never been done before'. His knowledge of the rules

▶ The chapel ceiling at Lambeth Palace, London
REPRODUCED COURTESY OF THE ARCHBISHOP OF CANTERBURY AND THE CHURCH COMMISSIONERS

This mural, painted in flow-consistency acrylics directly onto the vaulted, plaster ceiling of the chapel at London's Lambeth Palace, presented Leonard with an enormous challenge. He aimed to give a sense of history of the place from the point of view of a chronological narrative.

The ceiling is about 1300 sq m (1400 sq ft) and the work took around eight months to complete. The plaster was prepared first with several coats of acrylic gesso primer, after which the studies were transferred to the ceiling by squaring them up using a grid, charcoal and string. Once the resulting distortions had been readjusted, the panels were then painted using many layers of colour in a method similar to that used by Leonard for his paintings on canvas – except in this case he painted leaning back on a chair, supported by 14 m (45 ft) high scaffolding. The side panels were painted with five or six thin glazes of acrylic colour, until the right colour was achieved to link with the main pictorial panels.

Acrylics provide Leonard with an ideal medium for ambitious murals such as this

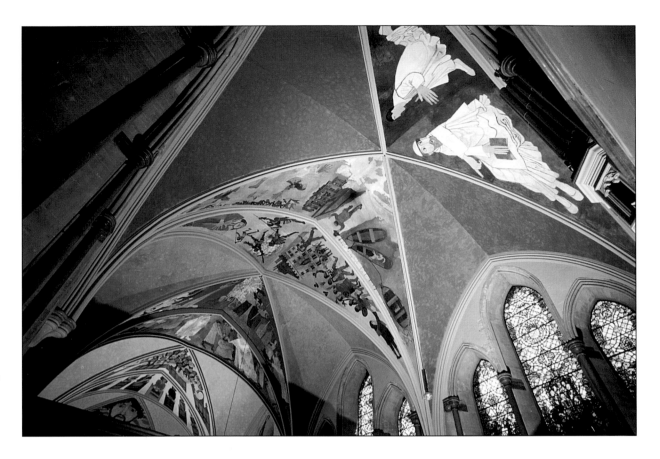

of perspective and observation of the work of early masters like Uccello and other fourteenth and fifteenth-century artists, reinforce his belief that it is 'perfectly legitimate' to change these rules and he emphasizes that you should always make perspective 'work for you'. Tilted-up floors, figures leaning at impossible angles, the odd spatial arrangements of inanimate objects, separate areas of perspective in one painting; all these elements contribute to the strong sense of theatre in Leonard's work and help to heighten its dramatic impact.

AN HONEST APPROACH

An interesting and perhaps unexpected piece of advice from Leonard for people who feel intimidated by the idea of tackling portraiture is to avoid worrying about getting an exact likeness: 'The most paramount thing is to forget about the portrait element. If you worry yourself to death about if it's going to look like your subject you will fail; I know, I've done it so many times. You must first make a painting which is true to yourself, which is your own even if it's totally unlike the sitter. If you can get to this state of mind you will carry the portrait element along with you. Go into the figure as a whole; don't worry about getting the facial elements right. Treat the details of the face as you would a bit of the curtain in the room – then see what happens and take it step by step.'

MASTERCLASS
with Jack Shore

Jack Shore takes advantage of bright acrylic hues to produce vibrant paintings whose colours resonate from the picture surface. He exploits the 'cleanness' of the colours, their matt quality and quick-drying nature of the paint to full effect to build up the many layers of flat, intense colour which characterize his still lifes and landscapes. The impression of bright colour in his paintings is strong, but his equal command of tone contributes to the powerful organization of his designs.

The space and three-dimensional form he perceives in a subject are deliberately flattened out on his picture surfaces so that his paintings are not so much representations of individual objects as sets of balanced, colourful shapes and patterns on a flat surface. The key to the successful combination of interpreting what he sees with what he seeks to achieve in his paintings lies in him getting the greatest possible variety of shape and colour in one painting with the greatest possible overall unity – something that only comes from constant practice and hard work. When he gets it right his colours zing and his paintings seem almost to envelop the viewer. As he says: 'If viewers feel that one of my paintings wraps around them rather than stops at the frame, then I may think I've done a good painting.'

It is important for Jack that he can continue working on, and making radical changes to an acrylic painting, often for many months, without the surface deadening to the extent that it has to be abandoned, as can happen with oils.

▶ Palm Tree, Tresco Gardens
acrylic on white paper pasted onto hardboard
810 × 810 mm (32 × 32 in)
Inspired by a number of pencil sketchbook drawings, in this painting there is a strong sense of the artist's delight in the luxurious growth and vibrant colours of this Tresco garden scene. The scale of the tiny figure on the path in the centre of the composition helps to make the viewer feel as if he or she is being enveloped by the plants, trees and foliage in this scene; an effect which is enhanced by the close-up viewpoint. The combination of the repeated touches of blues, greens, purples and pinks throughout the painting, offset by the creamy, highlit path, gives a softly, dappled sunlit luminosity and surface harmony to the painting

▶ *Jack Shore*

Materials and Methods

Jack was naturally drawn to the intense colours offered by acrylic paint ranges after many years of teaching textile students, who used similar colours extensively for working out their colourful fabric designs. He now uses acrylics exclusively for his paintings, preferring them for many reasons, not least because he is able to achieve dense colour by overpainting many layers without the delaying factor of

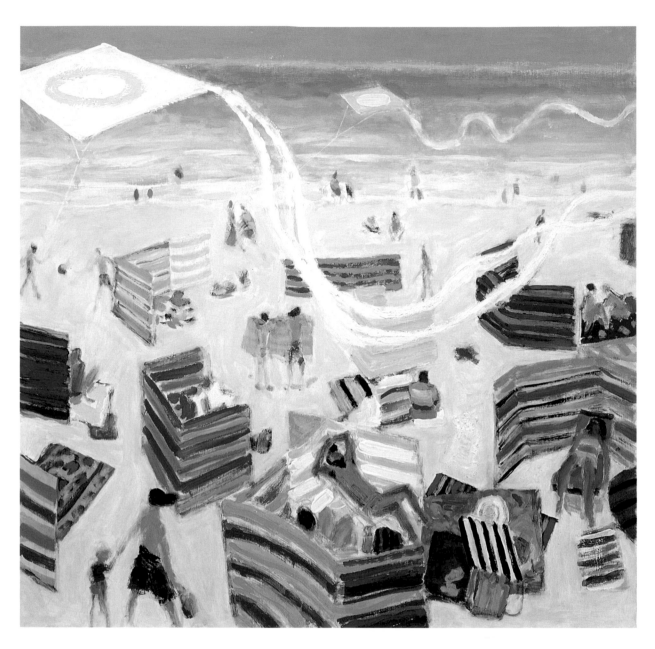

the longer drying time of oils. He also became 'very fed up' with not being able to conceal the texture of brush strokes with oils.

An obvious advantage of being able to overpaint quickly with acrylics, which Jack uses in his work in a way similar to many of the other *Acrylics Masterclass* artists, is that you can eliminate unwanted areas that do not work. He points out that if you are quick enough you can wipe off an area of colour that has not worked with a

Beach at St Ives with Two Kites
acrylic on hardboard
810 × 810 mm (32 × 32 in)
The apparent casual appearance of the design of this painting belies its strong organization; the rhythm of the kite is echoed by the second kite and in the pattern of the windbreaks, while the lozenge shape of the kites is a recurring feature throughout the painting. The figures have

become hieroglyphs, simplified from sketchbook studies; and in the background they have been reduced to single brush strokes. The overall effect of this high-key painting is of a bright, blowy day on the beach, full of activity; although Jack's overriding aim was to achieve the greatest possible variety with the greatest compositional unity in his manipulation of the elements of the painting

wet rag, without it leaving a trace. As he says: 'With acrylics you can wipe it off, do it again, wipe it off and do it again until it's right.'

He paints on either paper or 4mm hardboard; never on canvas as he does not like its 'give'. The choice of paper is almost always a smooth white paper with minimal surface texture, which he pastes onto a board. More often he paints direct onto prepared hardboard,

Garden Chairs and Yucca
acrylic on white paper pasted onto hardboard
810 × 810 mm (32 × 32 in)
This composition was intended to be a painting of the garden, with the Yucca as its main focal point. But when a chair was placed outside one day Jack decided to include it, as well as the second chair, which sets up a dialogue between the

two. The colour of the satchel on the foreground chair has been altered from black to red, then pink and yellow ochre and blue-grey, in order to work with the rest of the painting. The predominant blue throughout the composition has been applied to reopen the space of the painting which had become overclogged with texture

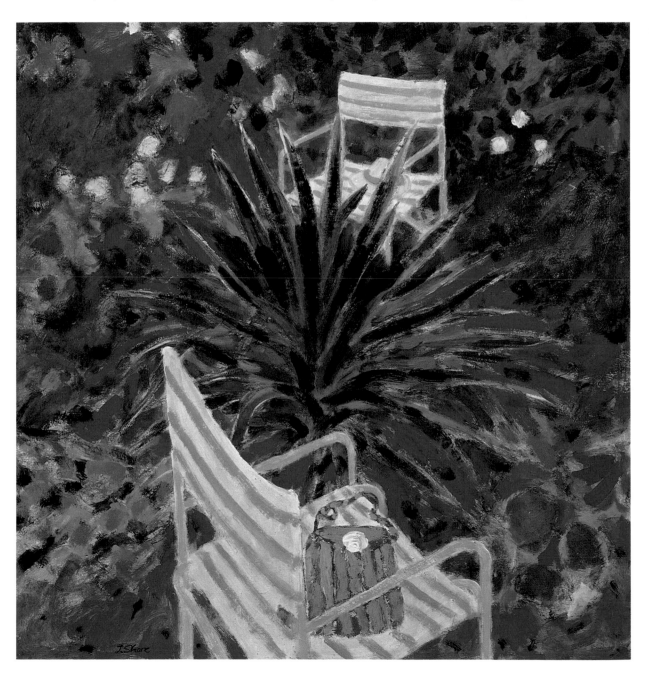

For some paintings Jack works on a table, as shown here, with his board propped up on a brick – on other occasions he will work flat against the wall, with his board resting on a ledge. He dislikes working at an easel because of the many distracting elements that you can see around the edges of a painting when it is on an easel. He uses liquid-consistency acrylic colours in bottles and mixes his colours on the tops of margarine tubs, trying out colours on test sheets before committing them to a painting. This he does in an almost irreverent manner, using worn-down nylon or bristle brushes and, later, sables for finer details. Plenty of water and rags are also essential to his working process

which he gives two coats of acrylic gesso primer, each one being laid on in opposite directions. This is given a tooth using rough sandpaper. Then, according to the intended painting, the ground is either left white or tinted with a warm or cool acrylic wash of an appropriate colour either before or after making the preliminary drawing. He may then intend to lay warm colours over a cool ground or cool colours over warm.

WORKING WITH COLOUR

Jack appreciates the vibrancy of the strong hues available in the best acrylic paint ranges. He works with a limited palette comprising: Black, White, Turquoise; Cobalt Blue, which he regards as essential;

Ultramarine, Cadmium Scarlet; Violet, another essential colour for achieving the range of pinks and pinkish blues typical of his work; Lemon Yellow, Cadmium Yellow; Monestial Green and Bright Green. He deliberately avoids mixing or using brown which, as he notes, 'kills the entire colour of a painting'. As Jack explains: 'Browns are really only degraded, desaturated reds from which the light has been withdrawn, so they're not giving off much energy. With browns you're taking your colour scheme down in tone so you're going to get a darkish painting – which I don't particularly want.'

To make colours work at their most intense Jack disperses his paints with water, or with white, until he achieves the most powerful colour value of a particular hue – something which he notes eludes many students. Violet, for example, straight from the tube appears to be almost black and needs to be dispersed in white before its colour value becomes apparent. It is important not to add too much white, however, or the colour will start to pale off.

In line with his belief that you must be prepared to make quite radical changes to a painting, Jack applies his colours vigorously to his painting surface in a way that seems almost irreverent. He enjoys what he describes as 'scrubbing' and 'stabbing' the paint onto the surface very quickly, as in the shadow areas on the pathway in *Garden Path, Tresco*. To do so he prefers to use worn-down brushes made of nylon or bristle; with half-worn brushes he shapes them by cutting off the ends to achieve a blunted worn-down effect. Later on he may use sable brushes to apply smaller detail or finishing lines.

Garden Path, Tresco
*acrylic on white paper pasted
onto hardboard
810 × 810 mm (32 × 32 in)
Although colour is important,
in this work, Jack's main
interest here is in the structure
of the composition, and with
an approach bordering on the
irreverent he has placed the
path — the predominant element
in the painting — right in the
middle of the design.*

*The path itself has been
through many changes of
colour, from white to orange to
yellow ochre, before becoming
its present creamy tone. The
shadows across it were
originally blue, then eliminated
altogether, before Jack took a
large bristle brush and stabbed
on the blue-violet shadow
shapes which in their dramatic
contrast with the light tone of
the path help to suggest strong
sunlight. In their echoing of the
colours elsewhere in the
painting, they also help to
harmonize the path with the
rest of the composition*

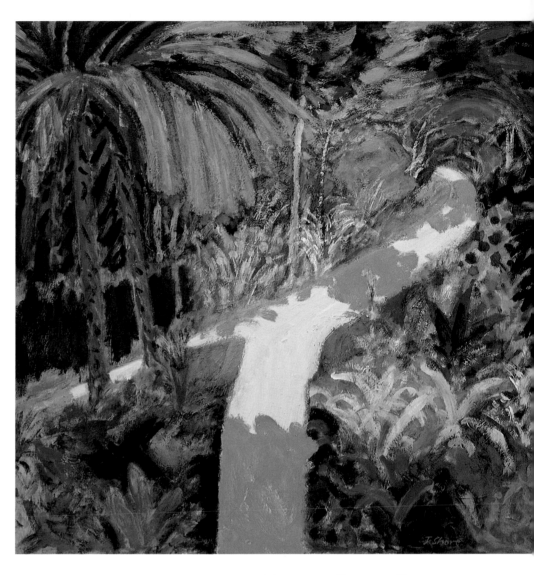

Although he takes cues from his subject when he starts a painting, Jack likes to make intuitive decisions as a painting progresses, and often alters colours drastically to make them work in juxtaposition with each other. He might decide to use a colour to harmonize with a red, or to change the sizes of colour areas to make them balance each other more effectively. He enjoys taking chances with colour and emphasizes that often it is the relative areas of colour that you use, more than the individual colours themselves, that can make a difference to the success or failure of a final painting.

MAKING A COLOUR CIRCLE

To gain a better working knowledge of colour Jack advises making your own colour circle, based on your own observation. As he says: 'I regard the text book colour circle as dangerous. Its colour is seldom true and it is accepted as a magical icon embodying secrets of colour, which it is not. A colour circle created as the result of personal experience of colour phenomena, such as complementaries, natural tonal progression and temperature value, is a very different matter, but the procedure for making it is too complex to describe here.'

Still Life on a Striped
Ground
acrylic on hardboard
810 × 810 mm (32 × 32 in)
Brightly coloured striped
materials are an obsession for
Jack and he frequently
includes them in his still lifes.
Here, the foreground striped
cloth helps to lead the eye into
the middle and background
where the objects are grouped.
In its bold colours and straight
lines it contrasts with, and acts
as a foil to, the visual fizziness
of the busy patterned material
and still-life objects in the
centre of the composition. The
foreground black jug sets up a
dramatic tonal contrast with
the white shape on which it
stands, as well as the white
stripes in the material, and
links the foreground to the
background by repeating the
black triangular shapes either
side of the gathered-in
background material. To
achieve this effect Jack
changed the jug from its
original green, with a white
handle, to one solid dark tone

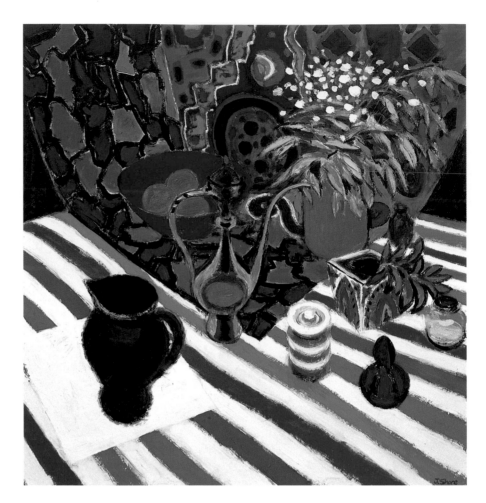

A PREFERENCE FOR STILL LIFE

Currently Jack concentrates on still-life subjects. Having been an abstract painter for many years, with a special interest in colour and proportion, he initially sought an alternative means for exploring these relationships through still life, just to get his eye in. He then decided to continue with the subject because, as he explains: 'The very act of perception is an abstraction that you can't put any words to. It's only when you try to put words to it that you stop seeing. If you look at a "leaf" you stop looking at it, but if you forget what it is you're looking at you see its shape, colour, the way light falls across it. You start seeing it as an abstraction. That's why I keep going with still life.'

PREPARATORY WORK

Jack begins a still-life painting by first arranging a group of objects in his studio on a large low table or chest, or both together, which he covers with brightly coloured, patterned materials such as beach towels, as in *Still Life on a Striped Ground*, dress fabrics or colourful rugs, and favourite objects such as a fluted dish, vases decorated with Chinese patterns and an octagonal shaped tin appear time and again in his still lifes. His aim at this stage is to organize a still life full of bright colour relationships, interesting contrasts of shapes, and patterns – in fact anything that will contribute a 'visual fizziness' to the scene might be included, 'however dreadful it might be as an object'.

Preparatory studies for Scattered Still Life with Chinese Willow Tray and Yellow Fabric
Once Jack has set up his still-life arrangement he draws it from a standing position, making quick sketches on sheets of paper attached to a clipboard using a 9ʙ graphite stick. This gives him a delicate line and the facility to make tonal areas.

In these early exploratory sketches he is looking for the most satisfactory viewpoint, compositional arrangement, scale, and tonal structure. Although colour intensity is the overriding feature of his work, this early familiarity with the interplay of tones is important for underpinning the vivid organization of the colours in his painting (1).

Next, Jack takes one of the tonal studies and isolates its linear structure by putting it up to a window, laying another sheet of paper over it, and tracing its predominant lines with a pencil (2). He then uses oil pastels to develop this, trying out colour relationships for the first time. Notice that here he has excluded the background patterned rug, which he considered too fussy for the composition, and has replaced it with an invented plain blue background. He has also eliminated the modelling and folds of the yellow cloth. Here you can see how he has developed the composition as flat areas of colour (3)

▲ 1

▲ 2

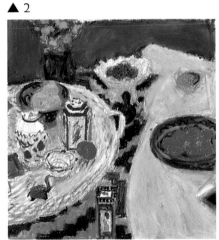

▲ 3

Flowers and fruit are often incorporated too, and he is not worried by the fact that their colours may change over time. Indeed it is something he relishes since alteration is a crucial part of his painting process. Once he has set up a still-life arrangement he might move things around, frequently after he has started to work from his subject; he may also add more objects, remove other elements as a painting develops, or even change the background – note, for example, the change from the initial patterned background in *Scattered Still Life with Chinese Willow Tray and Yellow Fabric* to a plain red.

EARLY DRAWINGS

His approach to a still life varies, although he almost always draws from it first. He stresses the importance of drawing from the subject because 'Even in the flimsiest drawing you start to see it properly – the relationships, space etc. You may not put everything down but at least the activity triggers you into seeing things you might not have seen when you set up the still life.'

If he is particularly interested in the structure or design of the still-life arrangement he draws it carefully on a small scale in pencil on paper, paying particular attention to the sculptural nature of the forms, their spatial organization and the scale and proportions of the objects.

In these early drawings he takes an intuitive approach to perspective, and only chases the lines of a still-life object back to its vanishing point if it really looks very wrong in his composition; normally he does not bother. He relies on his visual judgement and in any case regards the drawing or painting surface as a

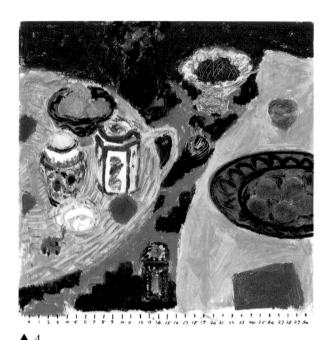

▲ 4

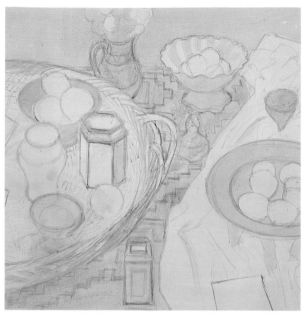

▲ 5

Scaling up Scattered Still Life with Chinese Willow Tray and Yellow Fabric
Further oil pastel or oilbar colour studies enable Jack to continue to explore the key shapes and colour values, before he finally decides on the best arrangement for his larger scale painting.

To translate his selected study to the 810 mm (32 in) square format of his painting he uses a system of coordinates in which he divides the edges of the sketch and painting surface into the same number of equal units, and uses a home-made 'enlargement ruler' to transfer the basic lines of the one to the other. This is usually done in hard pencil or occasionally with a fine sable brush and wash. He nearly always uses a square format because he likes the neutrality of the height to the width and the way in which this can be divided up compositionally (4)

flat plane on which you create 'aesthetic space – not the illusion of physical space. To reproduce planes in depth is just a piece of craftsmanship. You can do it but it's boring because when you've done it you've just created a hole through your picture.' Space in the aesthetic sense is of primary importance to him; he is not primarily interested in creating illusory space.

COMPOSITIONAL AND COLOUR STUDIES

Sometimes, once a compositional study is complete he enlarges this original drawing onto his painting surface using a system of coordinates, before starting to paint. This is quite different from squaring up, which destroys the rhythmical unity of the original study. The coordinate system used is more accurate than squaring up and it retains the spontaneity of the original sketch. This initial compositional design will then remain consistent throughout the development of the

Scattered Still Life with Chinese Willow Tray and Yellow Fabric
acrylic on hardboard
810 × 810 mm (32 × 32 in)
Jack then applies a blue acrylic wash to indicate the darker tonal areas. At this stage he is clarifying the most important compositional elements in the painting: the division down the middle of the painting into two main parts, linked by the pattern in between; the edges at which objects just touch each other; the overlapping and separated forms; all these are developed as abstract forms to enhance the design of the painting (5)

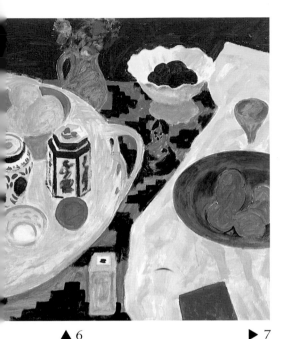

▲ 6

▶ 7

subsequent painting, although he may make fairly drastic changes to the colours and tones.

On other occasions, when he is less interested in repeating the actual arrangement of the still-life objects in his painting he might make one or two line drawings from his initial tonal study by putting it up to a window, overlaying another sheet of paper and tracing through. These tracings have a clarity of line and freshness that he likes to translate into his paintings; they also help to take him in different directions by suggesting new ideas for different compositions.

Colour studies in oil pastels or oilbars also contribute to this exploratory stage. In these he establishes the key shapes and colour values, blocking them in rapidly and laying down the colour fairly loosely. Separate colour studies of the same still life often reveal slightly different emphases and show him trying out subtle changes to colours and shapes as he searches for the 'right' composition and most exciting combination of hues.

Starting from the top he next blocks in the main colours and tones, beginning here with the red background. It is important for him at this stage to cover as much of the painting with colour as possible to give a feeling of the basic interplay of shapes. The paint at this stage is thin and transparent and applied in washes to act as an underpainting for later applications of colour; note for example the yellow ochre colour of the jug which later changes in colour and tone as a result of further applications of blue and darker reds (6).

After these further applications of thin transparent colour which have now modified and

changed the underlying hues, the final painting conveys only a cursory sense of reality in which the emphasis is on the aesthetic relationship between the shapes and colours, rather than on the reality of the objects themselves. Rather, they act as the fundamental elements in a visual drama of flat, vibrant colour (7)

DEVELOPING THE PAINTING

For Jack, developing the painting is a continual process that begins in the early sketches and colour studies and goes on sometimes even after a painting has been framed or comes back from an exhibition.

In his drawings he may have a framework from which to work, which will include clues about composition, placement of objects, shapes, rhythms, the counterpoint of pattern and flat areas of colour and colour relationships. When it comes to developing the painting, however, he may reinterpret this information, altering the interactions of colour and shape, and even sometimes the actual scale of objects quite freely as a work progresses. A hand mirror is useful at this stage for helping him to identify any compositional errors; its reverse image shows these up very clearly.

As the overall picture develops he responds quickly to the way a change or slight shift of colour or tone affects the whole feel of the composition and is quite prepared, for example, as in *Still Life on a Striped Ground*, to change a green and white jug to black if he feels it does not work visually.

A useful piece of advice from Jack on developing an acrylic painting is to stop worrying about how to make it look like the original subject, or relate directly to the early drawings or colour studies. His method for avoiding this is to concentrate on the abstract elements of the composition – shape, tone and colour, pattern, rhythm – which he extracts from the subject and reinvents, conscious always that he is dealing with flat shapes of colour on a flat surface. One of the formal aspects that works particularly effectively in his paintings is the

way he controls and offsets complex, colourful patterns with smaller areas of solid colour – note, for example, the solid areas of orange and yellow in *Still Life with Row of Sea Shells, Fruit and Flowers,* which offset the complex patterns of the different materials and offer the eye an area of visual repose in a busy surface which sings with colour.

Colour study for Still Life with Row of Sea Shells, Fruit and Flowers
Comparison between this oil pastel study for, and the final composition of Still Life with Row of Sea Shells, Fruit and Flowers *shows how Jack occasionally keeps to his original idea for a painting in terms of its structure and colour – unlike other works which change considerably during their development as new possibilities occur to him*

Still Life with Row of Sea
Shells, Fruit and Flowers
acrylic on hardboard
810 × 810 mm (32 × 32 in)
*This painting developed in a
straightforward manner with
few changes except for the
background, which has been
altered from yellow to green,*
*which now helps to throw
forward the sea shells, bananas
and oranges as a result of its
darker contrasting tone*

117

MASTERCLASS
with Ian Simpson

Ian Simpson exploits the quick-drying quality and versatility of acrylics to make finished landscape and cityscape paintings on the spot, as well as studies for studio oil paintings. In these works he manipulates the individual characteristics of acrylics to full advantage, applying the colours wet into wet, using more opaque applications in some areas, overpainting mistakes, scratching into wet areas with his brush handle to suggest grass or foliage or to break up a flat area with textural marks; sometimes using pencil, charcoal or ink on top to give an additional linear quality to the painting. Occasionally he might also use oil pastel, which acts as a wax resist when washes of acrylic are overlaid, to create interesting textures. This variety of surface effects enlivens the essential structural element of his work, and adds to the impact of his images.

For Ian, as for most artists, selecting a viewpoint and working directly from the landscape or in the city concerns more than just the desire to capture the appearance of the scene. His interest is in finding a subject and a viewpoint which will allow him to divide and then reconstruct what he sees in front of him into a series of 'interlocking shapes' on the picture surface. To help him to achieve this he selects a high viewpoint so that he is able to look down on cities and coastal scenes, which are his preferred subjects partly because the objects in them naturally form the pattern of interlocking shapes that he seeks to extract from the view.

▶ Burning Stubble Fields
*acrylic, charcoal and oil pastel on white cartridge paper 420 × 595 mm (16½ × 23½ in)
As it takes only a few minutes to burn many acres of field, Ian had to work rapidly by selecting a viewpoint, and fixing his attention on a particular moment.*

The study consists simply of three main horizontal areas of colour: a broad wash of black acrylic paint to indicate the blackened field, a green strip of landscape on the horizon, and the ochre band of unburnt field in the foreground. A fourth horizontal area of bare white paper has been left to indicate the sky. Details such as the trees on the horizon are indicated in charcoal; the puffs of white smoke were scribbled on in oil pastel; the black smoke behind suggested by a transparent wash of black paint. The lines of remaining unburnt stubble were hatched on using yellow oil pastel and a ruler laid across the paint surface to form a horizontal straight line along the bottom of these vertical strokes

◀ *Ian Simpson*

INTERLOCKING SHAPES

Although Ian's first thoughts are to find interlocking shapes in his subjects his paintings do, nevertheless, retain a keen sense of place. They can be seen as distilled, visual descriptions of the actual subject, underpinned by a strong sense of design and of the structural quality of natural and man-made environments. An even light is important when he paints on the spot in helping him to identify these significant shapes and structures, since powerful sunlight and strong shadows tend to camouflage such elements.

▶ Coastal Landscape,
Cornwall
*acrylic on white
cartridge paper
420 × 595 mm (16½ × 23½ in)
The high horizon line, not
much sky, and the high
vantage point so that we are
looking down over this coastal
scene, are typical features of
Ian's work. So, too, is the
grey, even light, which has
allowed him to focus on the
broad structure of interlocking
shapes that underlines this
landscape view.
The simplified shapes of the
sea, sky, foreground rocks,
middle and background cliff
faces and tops, all fit together
in a series of interlocking
forms. The paint has been
applied and built up in opaque
layers on the paper; the
retention in the medium of the
different sizes and directions of
the brush strokes contributes a
lively surface quality to the
composition. Space is suggested
by the contrast between the
large foreground shapes and
the sloping shapes of the cliffs
in the background*

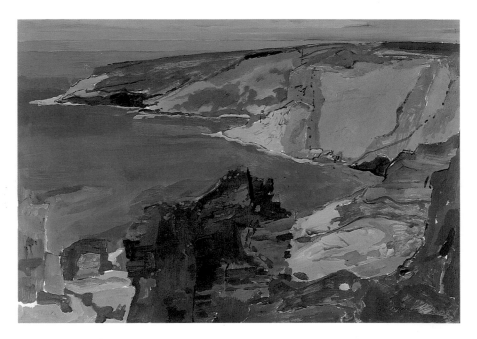

▶ A View of Cambridge
*acrylic and pencil on
white cartridge paper
595 × 420 mm (23½ × 16½ in)
This study was painted
standing at the top of a church
tower. The sky and general
shapes were blocked in first with
thinned colours, before the
architectural details were
developed in pencil. Our eye is
led into the work by the diagonal
lines from bottom left to middle
right, of which the receding
perspective lends a strong sense
of distance to the composition*

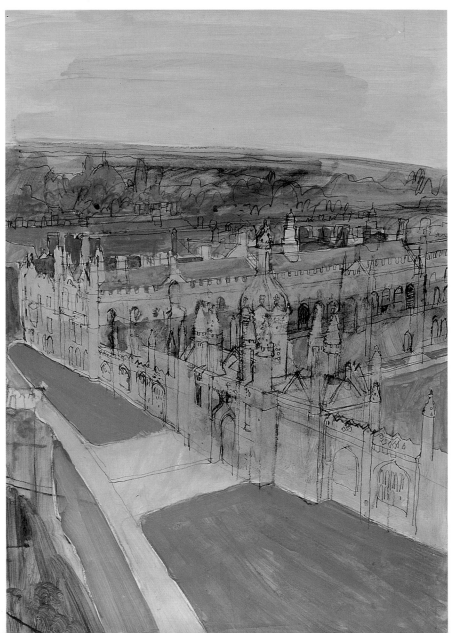

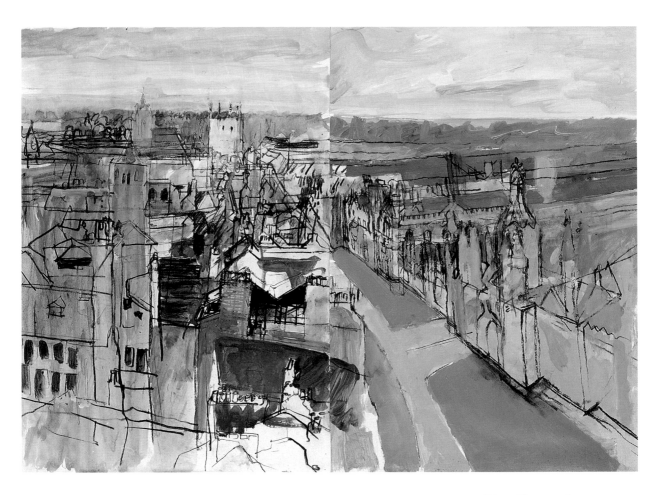

Ultimately, though, 'it's determination to paint that produces a painting, not the subject'.

Making a painting is equally about superimposing your own ideas onto a subject and allowing the composition to take over, as it is about selecting the elements that inspire you. Everything in Ian's paintings is made to fit into his desire to achieve an interlocking structural composition of simple but textured shapes inspired by his subject matter. Landscape elements such as water, for example, are included in some paintings, but they become structural elements within the overall design of the composition rather than enjoyed for their own special qualities: 'I'm not interested in reflections or the shimmering effects of light on water.' Skies, too, are important mainly as

Two Views of Cambridge
acrylic and charcoal on white cartridge paper
595 × 840 mm (23½ × 33 in)
This composition consists of two paintings joined together. The left-hand view was developed first, on the spot, from a high vantage point; the right-hand painting was then adapted from the study A View of Cambridge. *Each half combines the use of charcoal and broad areas of diluted acrylic colours, although the sky and colours in each work are very different, emphasizing the difference in light and weather conditions and the importance of both paintings as works in their own right*

shapes which complement and define other shapes; he's not interested in fleeting cloud effects and in most of his work the horizon line is kept well over half-way up the picture. In other works he has sometimes omitted the sky altogether.

At one time he avoided painting 'ordinary' landscapes, partly, as he says, 'because trees are fantastically difficult things to paint' and partly because he could not reconcile how to tackle them in the context of his overall aim to achieve a sense of structure and solidity in his compositions. Gradually, however, by looking at how Cotman translated trees into simple flat shapes, and at Nicholas de Stael's powerful distillations of landscape subjects, he came to realize that 'if you get the right colour and tone for the background and the right colour and tone for the tree, you can make it read as a three dimensional shape'. He learned from their example that 'you can create feelings of solidity and space without using descriptive shading or drawing; the answer lies in getting the right colour and tone'. Use of the 'right colour and tone' to achieve a successful suggestion of a tree can be seen in his painting of the Persimmon Tree, Arizona.

AN IDEAL MEDIUM

Ian first began to use acrylics in the late 1960s to make colour studies on the spot for oil paintings done in the studio. Now he makes acrylic paintings on paper in situ not only as the starting points for larger oil paintings, but also as finished paintings in their own right. Ian says these works 'are often better as there are a lot of things in these paintings done on the spot that can't be captured in the larger,

more considered paintings'. Not all the ideas contained in the acrylic paintings are worked up into studio oil paintings, however, since he only has time to work on one studio painting at a time, whereas he can make a series of paintings on the spot.

The works completed on the spot are done on paper of a convenient size for outdoor work. For the studio oil paintings, however, Ian works on a larger scale and a slightly more square format, which encourages the development of something very different from the original acrylic painting. He sees no point in 'copying' one painting into a larger version; he seeks instead 'to get the advantages of both worlds: the spontaneity of the thing done on the spot with the added dimension that comes from the structure being worked on for longer'.

Acrylics are ideal for using outside. As Ian says, 'the colours dry quickly, but not too quickly for you to paint wet-in-wet and you don't have the problem, as with oils, of taking a wet painting home. A painting in acrylics can also be developed much more quickly than in oils, which is an enormous advantage when working outside.' This was especially pertinent in the case of his painting of Burning Stubble Fields, the subject of which lasted only a few minutes. Another advantage is that 'you can overpaint and completely change something in a painting, and achieve effects in acrylics which can be reproduced in oils; for example, thickly applied brush strokes, wet-in-wet effects and the softening of one shape into another'. He recognizes their unique qualities, too, especially their versatility and the fact that you can paint 'on pretty well anything without initial priming'.

▶ Persimmon Tree, Arizona
acrylic on white cartridge paper 595 × 420 mm (23½ × 16½ in) Here, Ian has exploited the rhythmic pattern of the persimmon tree's branches and the overall shapes of its vivid orange-red fruits to create the impression of a dynamic living natural form. He has placed particular emphasis on the tonal contrast between the black trunk and branches and the lighter-coloured background shapes, which throws the tree into strong focus, while the patches of orange-red over most of the surface help to create a sense of compositional unity; they also contribute a colourful vitality to the painting

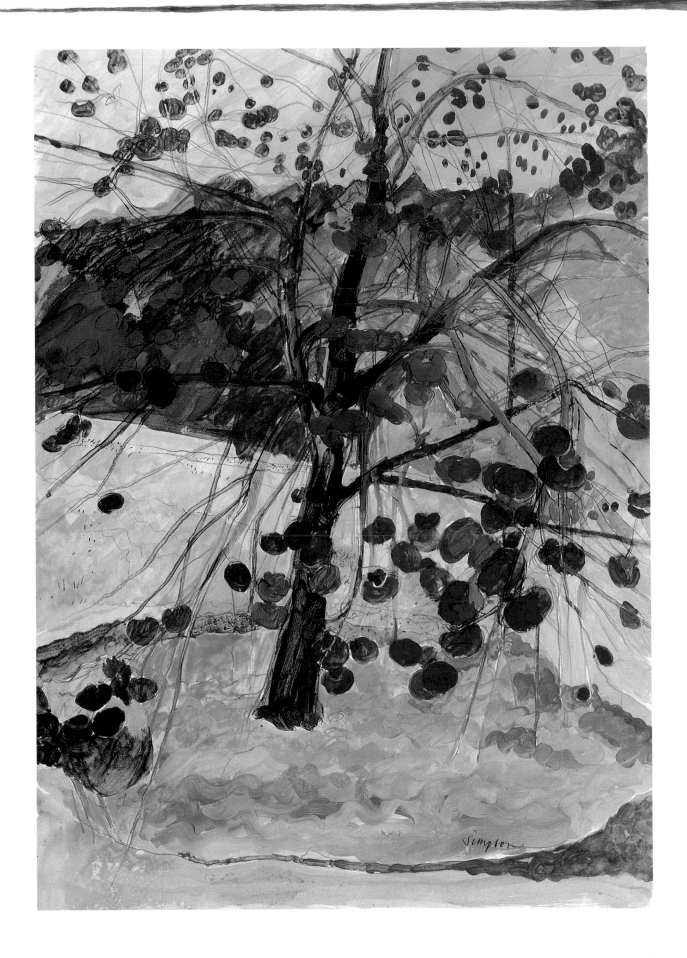

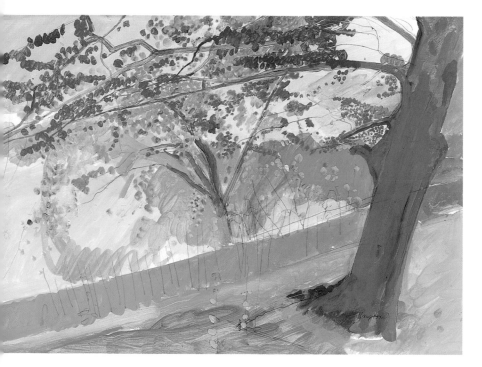

Working on the Spot

The position taken by an artist in relation to the subject is often crucial to the success of a composition. In many cases the foreground in a landscape painting will be its downfall because not enough consideration has been given to it from the start. Ian's strategy for avoiding this problem is consciously to paint from a short distance in front of him and to take his eye up from the foreground to the middle ground to the horizon, and approach his painting in a similar way. With this in mind he will either start by outlining the main elements of the composition on his white paper with pencil or charcoal, or he might block these in with thinned down Viridian or blue-grey acrylic paint. He makes good use of the buttery-consistency acrylics, which, as in *Coastal Landscape, Cornwall*, allows him to manipulate a variety of brush strokes to articulate what might otherwise remain as uninteresting, flat shapes of colour.

Having established the main elements of the composition he tries to keep the painting going over all parts of the picture surface, aiming to get it right at this second stage. But in practice all kinds of things happen: 'the first shapes might need adjusting and in changing them you change the whole composition; also, as you keep looking you might change your mind about the composition and the shapes you see.' And, of course, the accidents that happen in making adjustments wet-on-wet or on top of dried areas 'often turn out to be the most interesting areas'. One of the exciting aspects of working outside is in discovering, once you've got your work home, the things you cannot remember having done and, as Ian

Cherry Blossom Tree
acrylic and pencil on white cartridge paper
420 × 595 mm (16½ × 23½ in)
The dramatic contrast of the pink cherry blossom with the green field behind attracted Ian's interest in this view. Working on the spot he first indicated the main shapes in pencil before developing these by washing on broad areas of diluted colour. Often, as you can see especially along the darker green diagonal strip moving from bottom left to middle right, he draws through the paint while it is still wet with pencil, here to suggest a fence. The pink blossom, mixed from Crimson – unusual for Ian's palette – and White, has been suggested by applying thicker blobs of opaque paint with a smaller brush

He recommends acrylics to his students because they encourage a spontaneity in approach and because they allow you to make changes to a painting without getting into a mess. The use of acrylics helps to avoid the inhibiting 'preciousness' felt by many inexperienced painters who often reach a point with watercolours when they dare not do anything further to a painting for fear of 'spoiling' it, nor do you get the muddy chaos which can result from attempts to make changes to oil paintings. As Ian says, 'you don't get this with acrylics because once they're dry you can even overpaint white over black without churning up the colours underneath'. His advice to students who are more used to watercolour wash techniques is to realize that with acrylics 'you can have areas run together, but you can also put two areas of wet paint together that won't run – it comes down to practice and familiarity and the realization that you don't need to use too much water'.

says, 'these are often the best bits – which can be exhilarating and depressing because it sometimes seems that what you try to do is a waste of time and it's only the accidents that are any good!'

PHOTOGRAPHY AND PERSPECTIVE

As a painter who can only work by direct reference to a subject, and who aims to distil and record what he sees, Ian does not find photographs of a scene particularly useful as reference material, partly because photographs do not record how you actually see a view. When looking at a landscape subject you visually scale up background objects and see it from several viewpoints as your eyes scan the vista in front of you; a camera, on the other hand, records a view from a fixed viewpoint. To compensate for this discrepancy Ian has experimented with sticking together different photographs of a particular scene taken from different viewpoints, but on the whole he believes that 'photographs have very limited use. Sometimes they can jog your memory perhaps, but if you do use them they've got to become the subject of the painting and you've somehow got to forget the original scene. You've got to work from your photographs and drawings, as if you're working from the actual landscape.'

Truth to what and how he sees also affects Ian's use of perspective. As a work is constructed from slightly different viewpoints he does not necessarily try to make roads, for example, go to the same vanishing point. In his paintings of the view over Cambridge lines recede into the distance, but decisions

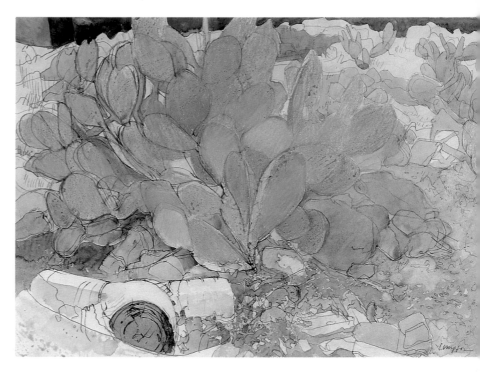

about how they recede were made entirely by eye, rather than according to any fixed rules. As Ian says, 'just like photography, perspective only works with the notion of a fixed viewpoint and you just don't see things like that. Photography and perspective actually disguise how you see.'

COLOUR AND TONE

The accurate interpretation of the major tonal areas of a scene through the choice and combinations of colours used is important for the expression of a convincing sense of depth and structure in a painting and leads, in turn, to the creation of the mood of a scene. This is an important part of Ian's thinking when he looks at his subject. He visually analyses the tonal effects that he sees, and selects and mixes his colours accordingly from a limited palette. This means that although his colours are chosen by direct reference to his subject, the

Prickly Pear Cactus, Arizona
acrylic, pencil and oil pastel on white cartridge paper 420 × 595 mm (16½ × 23½ in) Ian spent four hours on a cold December day working from this close-up view on the spot combining pencil, oil pastel and acrylic to suggest the texture of the cactus. The intricate pencil underdrawing helps to hold the composition together and contributes a graphic quality to the finished painting.

The cactus, the main focus of the composition, was first indicated in pencil, following its basic outline, after which its prickly texture was built up with the use of green and yellow oil pastels to indicate its colouring, followed by a wash of thinned green acrylic colour over the top. The oil pastel acted as a kind of wax resist, breaking up the overlaid wash to create this textural effect

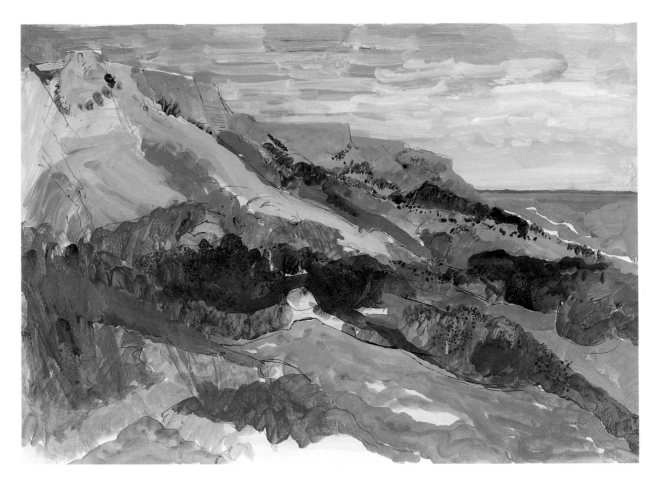

The Coast above
Walton-on-the-Naze
*acrylic on white
cartridge paper
420 × 595 mm (16½ × 23½ in)
The vivid orange, green and
purple colours of this Essex
coastal scene inspired this
on-the-spot painting, which
is characterized by an
underlying linear indication
of the main shapes and freely
applied transparent and
opaque areas of paint. The
ochre-coloured triangular
shape of the sea in the middle
right of the painting links it
with the colours of the coastal
rocks, although it is separated
from the landscape forms by
the simple indication in the
bare white tapering lines of the
breaking waves*

same kinds of colours and colour combinations appear again and again throughout his work: 'In practice you begin to develop a range of colours that you find interesting or know will go together and you identify and extract them from the original subject.'

His palette consists of Cadmium Red, Cadmium Yellow, Yellow Ochre, Ultramarine, Viridian, White and Black, which he uses to darken his colours. He does not use any pre-mixed browns; Yellow Ochre is useful for producing these with mixtures of other colours. Sometimes he will incorporate another colour into this limited range to make a specific colour not available to him by mixing from this selection. To make a purple, for example, he will mix Alizarin Crimson rather than Cadmium Red

with Ultramarine. Viridian is included in his palette to help him to make the more 'greeny greens' typical of his work.

Recently, he has been considering extending his palette to include two reds, two yellows and two blues to enable him to mix the 'widest possible range of colours from the primaries' because, as he notes, 'all the primaries are biased towards another colour – red towards blue, yellow towards orange and so on'.

His advice to students about using colour is to 'paint the colour you see – not the colour you know an object to be – and to try and paint the simple areas of colour, the key colour of a particular element of the scene rather than all its detailed colour nuances. That's what I try to do.'

ADVICE ON COMPOSITION

Ian's most fundamental piece of advice, and the principle behind his approach to painting on the spot in acrylics, concerns composition. As he says: 'Composition is the single most important element in a painting. The drawing, colour, all kinds of things can be wrong, but you can't have the composition wrong. Uccello's *Rout of San Romano* in the National Gallery in London has incorrect scale, different viewpoints, funny foreshortening, but it's still a marvellous, impressive painting which "hangs together". Turner and Cézanne weren't great draughtsmen, but their compositions are fantastic. Composition isn't just flat pattern; you must compose a picture in depth as well. Often the failure to get foreground, middle ground and background to work lies in the failure to make a picture three dimensional. You have to have compositional elements going into the picture, like a path reaching a hedge in the middle distance and so on; you have to have compositional elements in the picture that take you to these places in the picture space.'

Towards Lake Roosevelt, Arizona
acrylic on white cartridge paper
420 × 595 mm (16½ × 23½ in)
The sgraffito technique has been used here to suggest the blades of the black plant in the foreground of this hostile landscape scene.

Ian liked the combination in this view of the angular structure of the rocks in the background with the pale-green patterning on the foreground rock. Arid heat is suggested by the predominance of yellow ochre and orange, while the aerial perspective of the blue-grey background mountains, silhouetted against the paler sky, suggests a distant view beyond the rocks

Artists' Biographies

STOCKTON - BILLINGHAM
LEARNING CENTRE
COLLEGE OF F.E.

Terence Clarke lives and works in Worcestershire. His work has been shown in many solo and group exhibitions including the BP Portrait Award at the National Portrait Gallery. It is also represented in several public collections including those of the Contemporary Art Society, Granada Television and Dudley Museum and Art Gallery. Terence has also contributed to a number of art books and magazines.

Peter Folkes is vice-president of the Royal Institute of Painters in Watercolours and an Academician of the Royal West of England Academy. Following a career as a tutor and head of an art department in higher education until he retired in 1989, he now paints full-time and tutors and demonstrates for various workshops and painting holidays. He has had many solo exhibitions in the UK and USA and has contributed to numerous group shows. He lives and works in Southampton.

William C. Hook lives and works in Colorado. His special interest in light and colour has earned him widespread recognition in the USA; he has exhibited widely throughout the country and his work is represented in many private and public collections worldwide. His work has also appeared in several USA publications. In the early part of his career he worked in commercial art, which has contributed a powerful graphic impact to his paintings.

Moira Huntly is Vice President of the Pastel Society, a member of the Royal Institute of Painters in Watercolours and a member of the Royal Society of Marine Artists. She lives and works in Gloucestershire. Her work has been exhibited widely in solo and group exhibitions in the UK, USA, Canada and Europe, and is represented in many collections worldwide. Her publications include *Draw Still Life*, *Draw Nature*, *Draw with Brush and Ink*, *Imaginative Still Life*, *Painting in Mixed Media*, *Painting and Drawing Boats*, *Learn to Paint Gouache*, and *Learn to Paint Mixed Media*. She has also carried out many important commissions.

Donald McIntyre lives and works in Wales and regularly visits Iona where he spends the summers painting. He is a member of the Royal Cambrian Academy and has exhibited widely, including at the Royal Academy, Royal Scottish Academy and the Royal Society of Marine Artists. His work is represented in many private and public collections throughout the USA and UK, including those of the Welsh Arts Council, the Welsh Contemporary Art Society, HRH The Duke of Edinburgh and Robert Fleming Holdings Ltd.

Terry McKivragan started his career in commercial art before becoming a full-time professional artist in 1986. He is a member of the Federation of British Artists and exhibits regularly with the Royal Institute of Painters in Watercolour, the Royal Society of Marine Artists and the Royal Society of British Artists. His work is represented in many collections in the UK and he has carried out a number of commissions. He lives and works in London.

Leonard Rosoman OBE, RA, elected a Royal Academician in 1970, has had a long and distinguished career and is one of Britain's foremost contemporary figurative artists. An Official War Artist to the Admiralty from 1943–45, he has taught in many leading art colleges, and his work has been shown in many solo and important group exhibitions worldwide. His work is represented in numerous private and public collections, including those of the Arts Council, British Council, Victoria and Albert Museum, Imperial War Museum and National Portrait Gallery. He lives and works both in London and Long Island, New York.

Jack Shore spent fifteen years teaching at Blackpool Art School and twenty one years as Head of Chester School of Art before retiring from art education in 1981. Since then he has concentrated on painting full-time. His work has been exhibited in solo shows in the North West and North Wales and has been represented in the Walker Art Gallery, Liverpool, and is in public, corporate and private collections in the UK and USA. He has been a member of the Royal Cambrian Academy since 1961, including six years as president. He lives and works in Chester.

Ian Simpson is a past president and fellow of the National Society for Art Education and a former principal of St Martin's School of Art. He is a course leader, course author and Regional Organizer for the Open College of the Arts, which is affiliated to the Open University, and has written, edited and co-authored many books on drawing and painting, including *The Challenge of Landscape Painting*, *Collins Complete Painting Course* (ed.) and *Collins Drawing Course*. He has also written and presented three series of television programmes on art, and is a consultant editor to *The Artist* magazine. His work has been shown in several solo exhibitions and is in many public and private collections in Britain, Sweden and the USA. He lives and works in Suffolk and is a founder member of the Suffolk Group of artists.